The Golden Secrets of Lettering

NOTES ON

The Golden Secrets of Lettering

Thames & Hudson

Martina Flor

The GOLDEN SECRETS of Lettering

LETTER DESIGN FROM FIRST SKETCH
TO FINAL ARTWORK

Foreword
P. 7

Introduction
P. 8

1

Defining lettering and its difference
from calligraphy and type design
P. 10

2

The importance of
observation
P. 16

3

The DNA of letters
P. 28

4

Pens, brushes, and other tools
P. 50

5

An overview
of lettering styles
P. 64

6
COMPOSITION AND Embellishments

Structure, hierarchy, and flourishes
P. 88

7
Sketching LETTERFORMS

From rough sketch to refined drawing (and some helpful tips and tricks)
P. 102

8
FROM ANALOG TO DIGITAL

Vectorizing your lettering
P. 116

9
The Finishing Touch

Adding color and texture
P. 128

10
WORK IN PROGRESS

Becoming a professional lettering designer
P. 138

Acknowledgments and References

P. 166

CONTENT

What you'll find in this book!

The basics of letter design / optical adjustment / calligraphy basics / broad-nib and pointed-nib calligraphy

lettering styles / serifs and sans serifs / script, brush, blackletter, funky, decorative lettering / structure / distortion / embellishments / rough sketches / flourishes / digital drawing / coloring / texture / shadow / commercial lettering / pricing / scheduling / standards

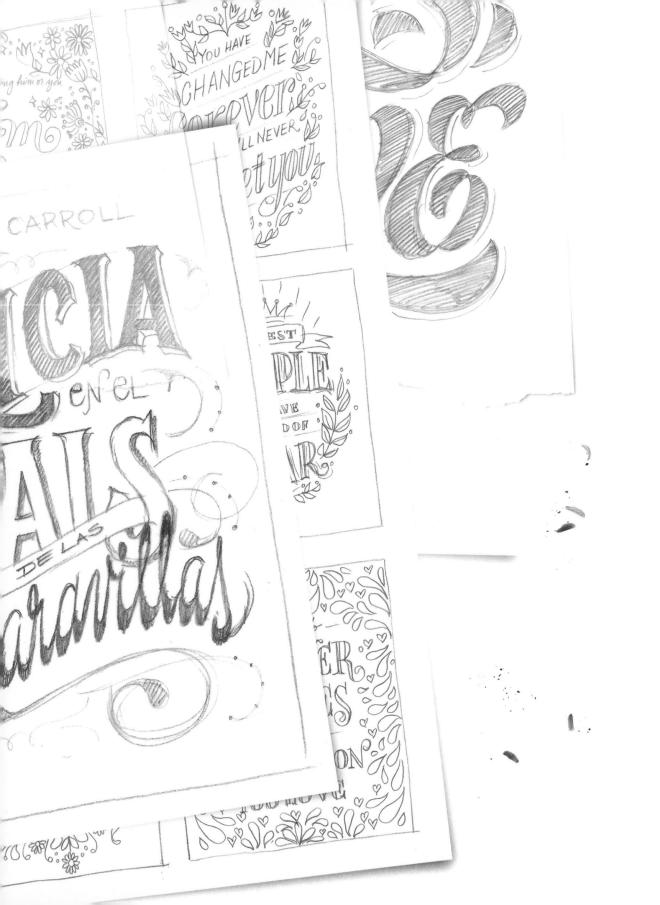

Foreword

Dear reader,

You have been tricked. You thought you bought a book that would teach you how to create lettering like a typographic artist. But Martina Flor is more than just a letterer, and this is more than a book about lettering. She is a brilliant designer and consummate professional with expertise in the minutiae of making shapes that are the result of a broad understanding of what it means to be a designer. In these pages she generously reveals an impressive range of techniques that will advance your skills not only in lettering but in the larger world of design.

Along with the revelation that the dots of an ellipsis are supposed to be smaller than a period (thanks, Martina, I didn't know that!), we also learn about the kind of paper we should use for sketching and how to price artwork. She explains not only how to use Bézier curves properly and how letterspacing works, but also how to read a brief and confidently follow the stages of a project, from the client's call to the delivery of the final file.

Because I'm an old-timer, my design education lacked the typographic resources that are widely available nowadays. Thanks to the plethora of websites, books, videos, and schools specializing in the subject, the world of lettering is reaching unprecedented heights. As a self-taught designer from an era when all of the above did not exist, I learned through trial and error while working in the field. Of all the literature available on the subject right now, I wish I had had Martina's book when I started my career—it would have saved me from many embarrassing mistakes.

Now, please excuse me while I go fix the ellipses in all of my fonts.

Matteo Bologna
Founder and principal of Mucca Design

About This Book

We are surrounded by letter shapes: we see them on the bus, on the packaging of the sugar we put in our coffee, on the storefront of our local bakery, on our computer keyboard, on our toothbrush. All sorts of things are printed with letters that someone more or less carefully planned and designed.

Since the dawn of mankind people have felt the need to give our language an image. Nowadays, with the rise of new, ever-faster methods to create letterforms and typefaces, thousands of digital fonts of various shapes and kinds are within our easy reach. In this context it is not surprising that the love for custom, handcrafted typography is having a renaissance.

This book concentrates on the process of drawing letter shapes by hand, i.e., the art of hand lettering. However, our goal is not to make imperfect, quirky, handmade-looking type, but rather to create well-shaped, polished, exquisite lettering that is finally digitized. We are not concerned with calligraphy or type design but rather with the kind of precise, high-quality lettering that sign painters used to do. To that end, we will first sketch our letters by hand and then digitize our sketches using a vector drawing software.

But first we will train our "typographic eye" by looking at lettering samples found on the streets. Then we will dig into essential concepts of letter design and have a look at the art of calligraphy to understand its influence on the anatomy of letters. After that we will start to explore our playground as letter designers and will discover the many different ways of creating letter shapes. Learning about concepts of hierarchy, composition, and flourishing will help us structure and plan our lettering. Once we have a rough sketch in hand, we will find out about drawing techniques that we can use to refine our design. Then we will move on to the digital environment and vectorize our letter shapes. We will finalize our piece by coloring it and adding texture.

In addition, I will share some insights about the commercial work of hand lettering. I will describe the most common kinds of commissions and give advice on how to reach out for clients and how to showcase your work.

Finally, I will guide you step by step through the process of a typical commission, from producing the artwork to communicating well with and getting feedback from your client—an essential part of the job if you want to build a sustainable career as a lettering artist.

Before we get started, I want to stress that this book shows just *one* way of doing things: mine. It is informed by my personal experience of working as a commercial letter designer, by all the teachers and colleagues I was lucky enough to learn from, and last, but not least, by my involvement in teaching at universities and private workshops.

In my workshops and classes I have worked with all sorts of people, including those with a background in creative professions, such as architects, designers, and illustrators, as well as those with no previous experience, including law students and housewives. What I have learned from dealing with so many different kinds of students is that everyone can learn how to draw letters. All you need to do is practice.

As a student of type design, I learned how to create highly legible, basically neutral letter shapes. The biggest challenge for my own development as a hand letterer was therefore to achieve expressive, outspoken, and colorful pieces of lettering. I had to go from the systematic, black-and-white, concept-free methodology of a type designer to a craft that combines letter shapes with colors and textures in order to tell a story and to deliver a message.

Loosening my hand while developing a smooth, organized way of producing commercial artwork consistently was the hardest thing I had to learn.

My aim with this book is to share all I have learned through trial and error. Rather than showing pretty alphabets that you can copy and color, this book will provide you with concepts, tools, and techniques that will guide you in your own path to hand lettering. Be ready to find out about them and make them your own. After reading this book, you will see letters in a totally new way!

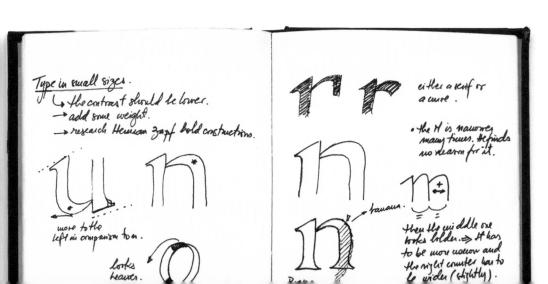

Sketchbook with notes on type design basics from my studies in type design in the Netherlands.

Chapter 1

What is calligraphy?
What is type design?
What is lettering?

applications

1

·VISUAL·

Storytelling

Defining lettering and its difference
from calligraphy and type design

What Is Lettering?

The term *lettering* refers to a unique, personalized typographic expression, made for a certain application by combining shapes and graphic elements, such as color and texture, in order to convey a certain attribute, message, or idea.

Lettering, in short, tells a story by using drawn letter shapes. These letterforms are not fonts that can be bought and simply used over and over again. Rather, they are custom-created for one particular piece and purpose. In this sense, they can be compared to an illustration—an illustration consisting of letters.

Lettering is often confused with type design. A type designer, however, focuses on creating an entire alphabet in which individual letters work together in every possible combination to form words and sentences. Typefaces are concept-free and acquire a certain tone or communicate a certain message depending on how a designer or typographer uses them and combines them with images and colors within a layout. A typeface's connotation is thus defined by its use.

Lettering is also not the same as calligraphy, the "art of beautiful writing." While a hand letterer draws letters from scratch, a calligrapher executes letterforms according to a model or freehand. The value of this art arises from the imperfection and spontaneity that are the result of the hand maneuvering a writing tool in a certain space and time. Each piece of calligraphic writing is unique.

While lettering often imitates the spontaneous manner of calligraphy, it is actually the product of many careful design decisions about how a particular curve or shape should look.

Although all three disciplines deal with letter shapes, the processes and amount of time they take are radically different for each. A type design project often takes months, even years. The work of a hand letterer is usually dependent on a client and must meet (often tight) deadlines. Lettering commissions normally take a few weeks. Calligraphy projects last only a short time—as long as it takes the hand to execute a particular text—although the process may be repeated.

Type Design

A type designer creates a full alphabet, which is then saved as a font. It is a modular system, with each module consisting of a letter that works together harmoniously with the other letters in the system in every conceivable combination. A typeface is concept-free and can be used over and over again in a variety of projects of different kinds. It acquires meaning and connotation only through its use with other design elements within a layout.

Calligraphy

A calligrapher masters the art of writing. By using different tools the artist embraces variety and spontaneity. Since calligraphy is the result of a hand moving in a given time and space, the resulting artwork is unreproducible and unique. Calligraphy does not involve typefaces; rather, it is based on certain individualized writing styles.

Lettering

→ This is what this book is all about

A hand letterer designs a word or series of words for a specific application with the goal of conveying a certain message or attribute. The letterforms' use is limited to the application they were designed for, and every letter is drawn from scratch.

Applications of Lettering

POSTERS

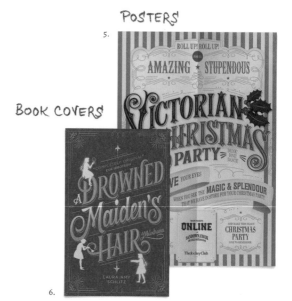

5.

BOOK COVERS

6.

Lettering can be applied on any object that can be printed, carved, or embossed with letter shapes. You will find some typical applications listed here. Often lettering is used as a signal of individuality, craftsmanship, tradition, or high quality.

OBJECTS

1.

3.

INVITATIONS

For example, lettering is widely used in branding as a way to create a distinct identity that differentiates a brand from all others while communicating certain attributes and values associated with it. In these cases, the design is influenced by many factors: the mark must be legible and easily recognizable, work at different sizes, have a color and black-and-white version, and fulfill other constraints.

4.

NUMERALS

2.

ART PRINTS

Lettering is also often used for editorial purposes, for example accompanying articles or on magazine and book covers. It may also act as a decorative element, applied on apparel and merchandise or interior design elements. Since in most of these cases there are no restrictions other than format and number of colors, the final artwork may be more expressive, colorful, and freestyle.

MAGAZINE COVERS

PACKAGING AND LABELS

8.

9.

APPAREL

10.

LOGOS AND LOGOTYPES

FLOURISHES

12.

OPENERS

13.

HEADERS

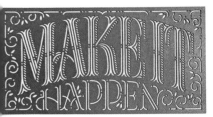

EPHEMERA

15.

ADVERTISING CAMPAIGNS

17.

POSTCARDS

18.

MERCHANDISE

19.

1. Invitation to the wedding of Eni and Luca
2. Art print for self-promotion
3. Print on a woodblock for the "Good Type" workshop series
4. Decorative figures for Variety magazine. AD: Chris Mihal
5. Poster for Sandown Park. AD: Scott McNamee
6. Book cover for Walker Books UK. AD: María Soler Canton
7. Magazine cover for 11 Freunde magazine. AD: Sabine Kornbrust
8. Label for Bluelime. AD: Josefina Alvarez
9. Design for Beyond Tellerrand Conference
10. Logo for Matt Murphy Illustration
11. Initial for LetteringvsCalligraphy.com
12. Opener page for AD magazine Spain. AD: Patricia Ruigomez
13. Header for Der Spiegel. AD: Jens Kuppi
14. Stencil card for self-promotion
15. Advertising campaign for FontShop. AD: Claudia Guminsky
16. Notecard for Harrods. AD: Pippa Kate Bridle
17. Postcard for Handsome Frank. AD: Tom Robinson
18. Tote bag for KFC. AD: Charlotte Khushi
19. Mug for self-promotiom

and much, much more...

From:
Buenos Aires, Rome,
Berlin, The Hague,
Barcelona, and more!

Chapter 2

• Examples of
 vernacular lettering

CRITIQUE

Observation

2

The Typographic Eye

The importance of observation

Training Your Typographic Eye

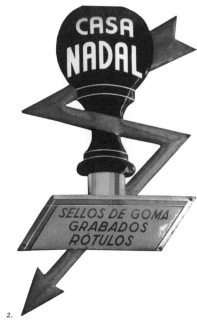

2.

The power of observation is a tool that enables us to analyze shapes and evaluate designs by others—which is incredibly helpful for our own design process.

The ability to recognize features in letter shapes can be improved through practice. The more you study examples of lettering, the better you will be able to judge a certain typographic piece. With time your typographic eye will become more accurate and you will be able to recognize even minimal variations between letters.

How can you hone your observation skills? A first step is to start looking at lettering with a critical attitude. This involves trying to discover the logic behind it. You can analyze a typographic piece from its overall picture to its particularities—in other words, from the obvious (the big picture) to the not so obvious (the details). The details can help you understand the larger whole, much the same way that you can comprehend how a certain machine works by looking at the individual pieces of its mechanism.

The easiest way to train your eye is by studying the lettering you find around you. First, identify the design's overall shape. For example, you can ask yourself why a certain street sign was designed in a particular way and what connotations and qualities the sign is trying to convey. Are these letters "friendly" or "serious"? Are they modern or traditional? Is the sign expressing softness or rigidity? How are its letters shaped in order to give that expression? It is helpful to think about whom the sign targets and which set of letterforms and elements it uses to talk to its intended audience.

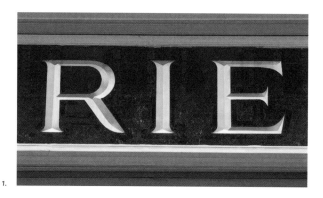

1.

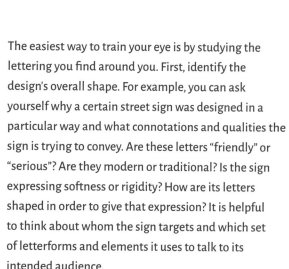

5.

1. *Paris. Storefront. Photo by Jean François Porchez*
2.–4. *Barcelona. Photos by America Sanchez, from Barcelona Grafica, Editorial Gustavo Gili*
5. *Car chrome lettering.*
6. *Rivera Lodge. Pinedale, WY. Photo by Stephen Coles*

Observing means looking, analyzing, and putting our impressions into words. It is also about discovering the relationship between the parts of a whole and understanding why they look the way they do. Once you have studied the overall shape, you can move on to the individual elements and their particularities.

A practical approach to this is finding basic shapes and grouping them. In our alphabet we can find letters that are predominantly rounded, such as the *e* and the *a*. On the other hand, there are letters that are mainly defined by their vertical strokes, such as the *n*, *t*, and *i*. You can thus group and compare letters and study the relationship between their shapes. Similarly, you can take a look at the stroke widths and endings: Are they thick or thin? Are the endings sharp or rounded? Are they applied consistently across the whole word?

On the following pages, we will look at samples of lettering found on the streets and study and analyze their parts.

4.

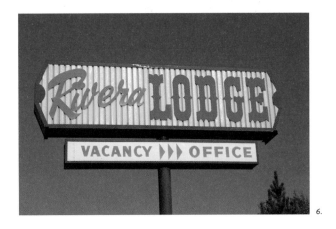

6.

Shadow

Decorative elements
are larger in capitals

The widths are similar
but _not_ the same

SIMILAR STROKE
ENDINGS

LA QUERENCIA

This is a
capital letter

These letters are smaller
but they look like
capital letters

Buenos Aires

The serif of the _L_
is related to the
middle stroke of the _A_

NOTE THE
MANY LAYERS

1
2
3

SERIFS

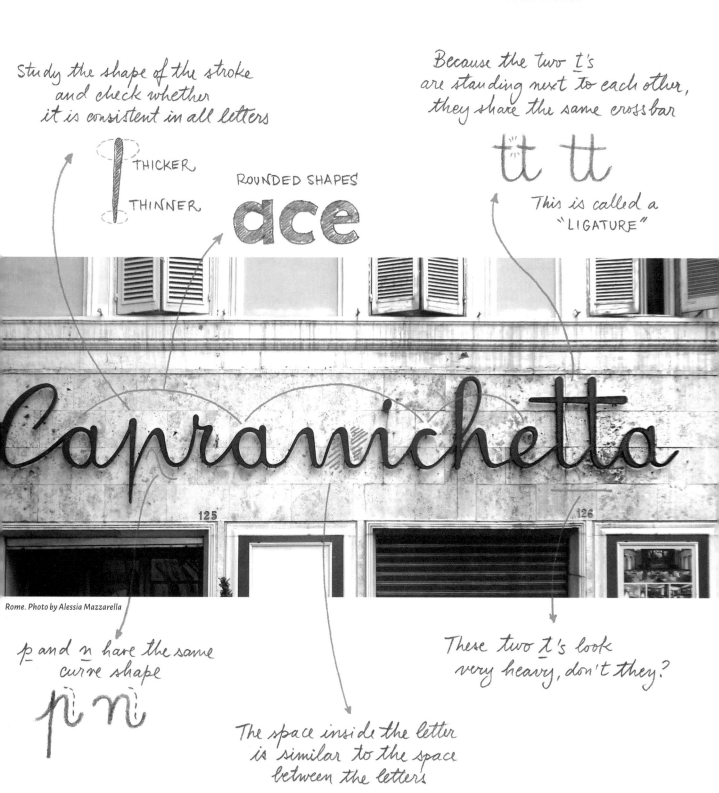

Study the shape of the stroke
and check whether
it is consistent in all letters

THICKER

THINNER

ROUNDED SHAPES

ace

Because the two t's
are standing next to each other,
they share the same crossbar

tt tt

This is called a
"LIGATURE"

Rome. Photo by Alessia Mazzarella

p and n have the same
curve shape

p n

These two t's look
very heavy, don't they?

The space inside the letter
is similar to the space
between the letters

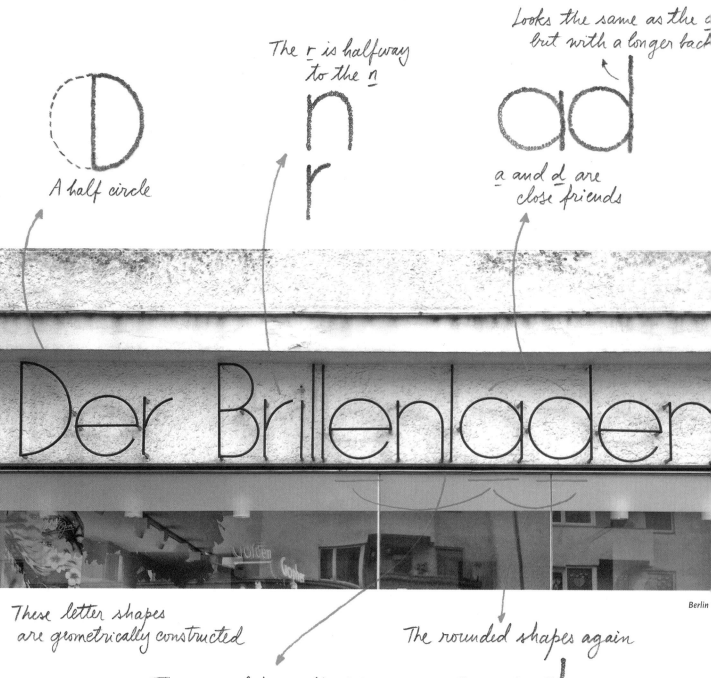

A half circle

The r is halfway to the n

Looks the same as the *a* but with a longer back

a and d are close friends

Berlin

These letter shapes are geometrically constructed

The space between the letters is very tight!

The rounded shapes again

How many ways
can you draw a
lowercase f?

------- f f f ------- and so on...

The capital letters
are much fancier than
the lowercase letters

The f and the r
share this curly feature

Oh my,
where to start...

Amsterdam

The terminals
are similar

The R and B are
constructed the same way
R B

How many ways
can you draw a d?
d d

What a weird r!
Its terminal is very unusual

The stems
are straight

Compare two rounded shapes

The e is also very wide

Looks good, right? But there's a lot to improve!

Their basic shapes are different. Weird...

Barcelona

The u is extremely wide

All letters have the same slant. Nice!

Here three strokes overlap and cause a dense spot

The width of the stroke
is consistent

↑

"SAUSAGE LETTERING"
appropriate for a butcher's
shop sign

The shapes
of all rounded letters
are related

Berlin

The "eyes" of the *l* and *e*
look similar

The letters are joined,
just as in handwriting

Related shapes

The *r* is
hard to read, isn't it?
What other *r* shapes
do you know?

All letters are connected except for these two. Why is that?

STARTING STROKE

These sharp edges repeat

ENDING STROK

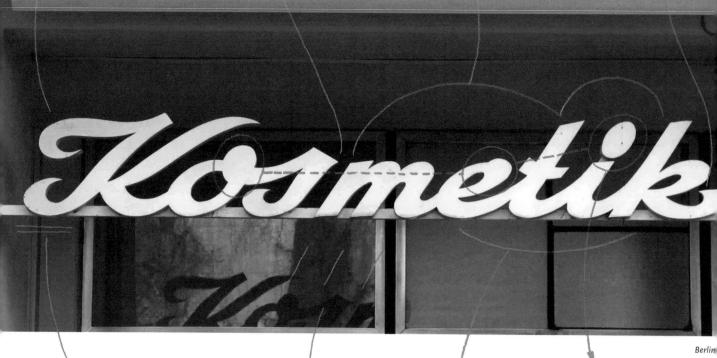

Berlin

The stroke endings are related

The letters have a consistent slant

Look at the e and the k. They have the same "eye"

These shapes have the same weight

EYE

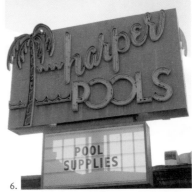

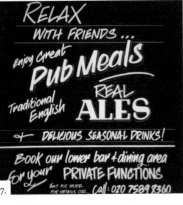

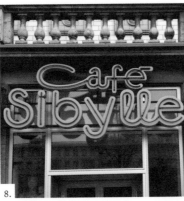

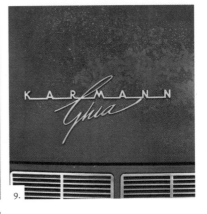

1. Barcelona.
 Photo by @l_lauraseguer
2. Amsterdam.
 Photo by @retypefoundry
3. Zilina, Slovakia.
 Photo by @typeatlas

4. Prague.
 Photo by @typeatlas
5. Paris.
 Photo by @typofonderie
6. Bakersfield, CA.
 Photo by @stewf

7. London.
 Photo by @martinaflor
8. Berlin.
 Photo by @martinaflor
9. Car chrome lettering.
 Photo by @stewf
10. Berlin.
 Photo by @martinaflor
11. Paris.
 Photo by @typofonderie

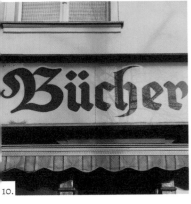

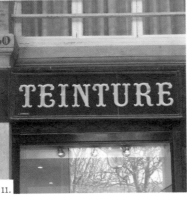

*Are you on Instagram?
Search for #goldensecretsoflettering
to find more signage awesomeness*

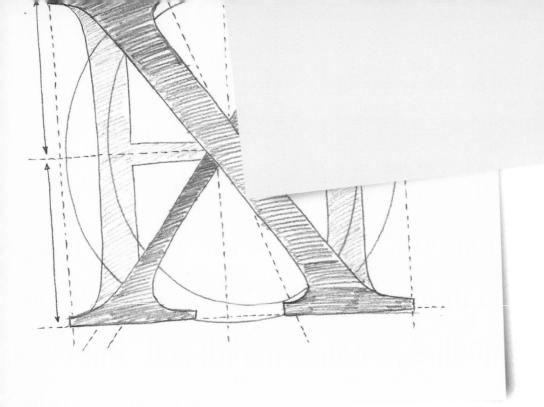

Chapter 3

- Terminology
- Basic shapes

 CAPITALS AND LOWERCASE LETTERS

- Optical adjustment HERE
- Spacing

- Weight and contrast

- Numerals

- Punctuation marks

3

THE BASICS

The DNA of Letters

Basic Terminology

When working with letters, we need to speak a
common language by using a specific terminology. We
don't talk about the "feet of the letters," for example,
but about "serifs," and we don't talk about a "round
thing hanging from the *a*" but a "drop terminal." The
following pages introduce you to some of the most
important terms.

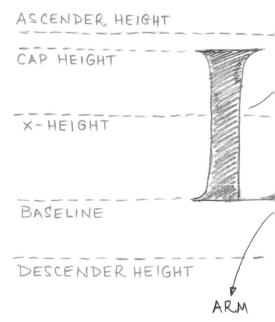

ASCENDER HEIGHT

CAP HEIGHT

X-HEIGHT

BASELINE

DESCENDER HEIGHT

ARM

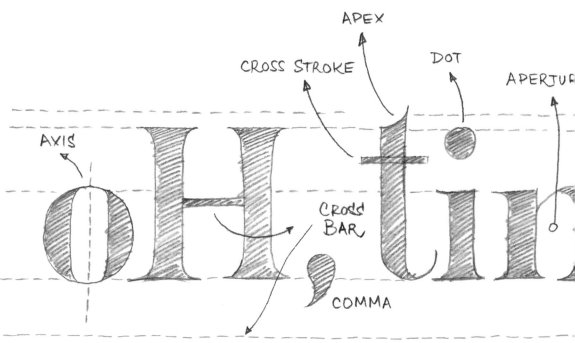

APEX

CROSS STROKE

DOT

APERTURE

AXIS

CROSS BAR

COMMA

also in...

A

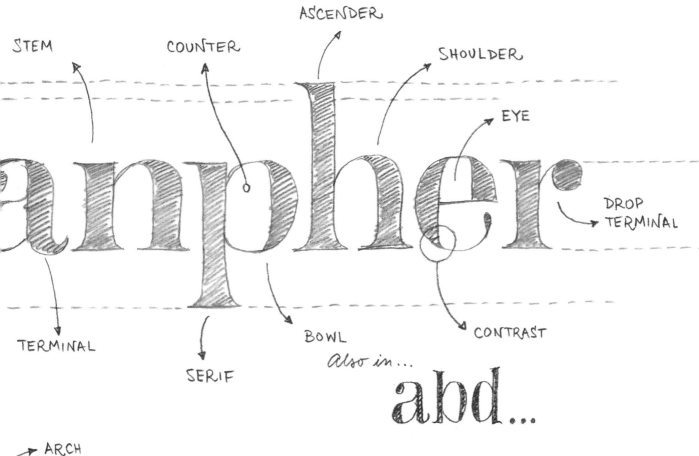

STEM

COUNTER

ASCENDER

SHOULDER

EYE

DROP TERMINAL

TERMINAL

SERIF

BOWL

CONTRAST

also in...

abd...

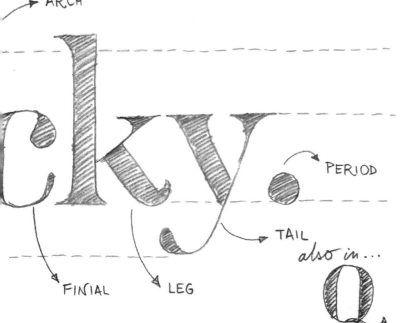

ARCH

PERIOD

TAIL

FINIAL

LEG

also in...

Q

CAPITAL LETTERS REACH THE CAP LINE

LOWERCASE LETTERS ARE MAINLY CONTAINED BETWEEN THE BASELINE AND THE X-HEIGHT. SOME HAVE ASCENDERS AND DESCENDERS

Here are some additional terms that come up often when working with lettering. This is a small selection of some of the most commonly used terms; there are, of course, lots more!

LETTERSPACING OR TRACKIN
The distance between
two letterforms

WORD SPACING
The distance between
two words in the
horizontal direction

LINE SPACING
The distance between
two baselines in the
vertical direction

VERY WIDE VERY NARROW

WIDTH How wide the letters are

VERY THICK VERY THIN

WEIGHT How thick the letters are

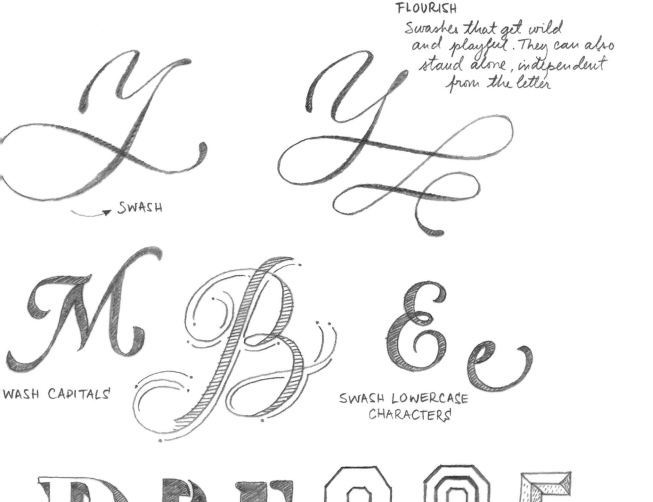

FLOURISH
Swashes that get wild and playful. They can also stand alone, independent from the letter

SWASH

SWASH CAPITALS

SWASH LOWERCASE CHARACTERS

SHADED OR 3D SHADOW STENCIL OUTLINE INLINE EMBOSSED

and many more...

APEX

BALL TERMINAL

DROP TERMINAL

LIGATURES
Two or more letters that are joined. Sometimes this even creates a new character

st ffi

ſs → ß

& Et

AMPERSAND
The ligature between E and t. Et means "and" in Latin

&

Ligature

SLANT The degree to which letters are slanted

(+) (-)

h h h h

DIACRITICAL MARKS
Symbols that are added to letters in order to change their sound values

ACUTE ACCENT
UMLAUT OR DIERESIS
RING
CEDILLA

á ê ö ù å õ ç ø

CIRCUMFLEX
GRAVE ACCENT
TILDE
BAR

and more...

ITALICS

an

CURSIVE

an

(HANDWRITING)

LOOP

CURL

EURO

DOLLAR OR PESO

...RLING OR POUND

CENT

LATIN AND NON-LATIN WRITING SYSTEMS

Latin script, also known as Roman script, is the most widely adopted writing system in the world. However, there are many other writing systems, and the principles of drawing letter shapes differ in each.

Non-Latin writing systems also have different directions of writing. Japanese script is written from top to bottom and from right to left. Arabic script goes from right to left.

→ In this book we will be working with this writing system

DIRECTION OF WRITING →

The content of this book deals exclusively with Latin script. Nonetheless, many of the lettering principles discussed here can also be applied to Greek, Cyrillic, and other scripts.

DIRECTION OF WRITING

DIRECTION OF WRITING ←

The writing direction and letter shapes vary according to the writing system

Basic Shapes: Capitals

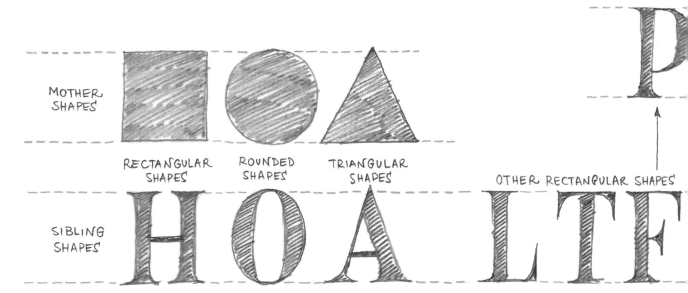

As we have seen in the previous chapter's typographic safari, there are certain basic forms that can be discovered in letters. Identifying these "mother shapes" allows us to group letters that are "siblings" and design them based on the same criteria and shared features. We are looking for the DNA of letterforms.

There are three basic shapes on which our alphabet is based: the square, the circle, and the triangle. We can quickly and intuitively organize certain letters by these shapes: the *H* and *I* are based on the square, the *O* and *C* on the circle, and the *A* and *V* on the triangle, for instance.

There are, however, certain letters that share characteristics of two of these groups, and to design them, we have to take DNA from both shapes. Once we have decided what the letters *O* and *H* should look like, we know how a rounded stroke and a straight stroke look. Therefore, we can easily draw letters such as *D, G, P,* and *B.*

Once we know what an *A* looks like, we know how a diagonal stroke should look, so we can go on to draw the *K, X, V,* and *W.*

Shapes cannot be simply combined as if they were Lego pieces, however. Each letter requires adjustment, and no curve or stroke will look exactly the same.

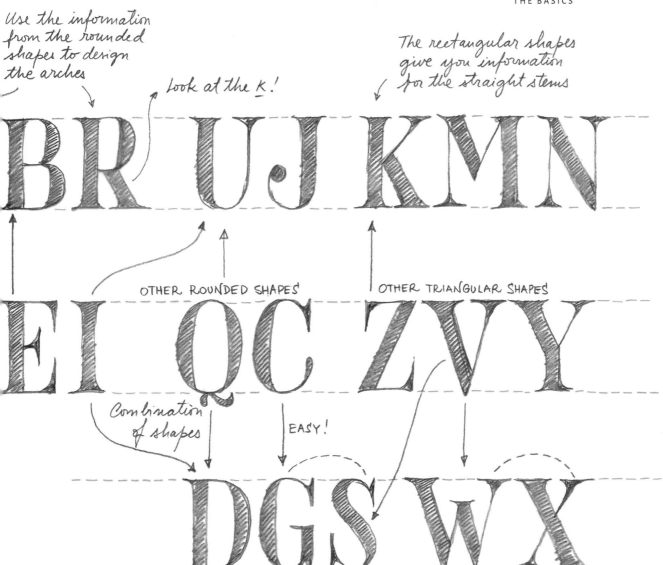

Use the information from the rounded shapes to design the arches

look at the K!

The rectangular shapes give you information for the straight stems

OTHER ROUNDED SHAPES

OTHER TRIANGULAR SHAPES

Combination of shapes

EASY!

When we design letters, we are shaping the image of our language; therefore, we should always design entire words and sentences. Designing letters is not about shaping individual characters that are then combined with other characters to form a word. Isolating a single letter will make it look strange when put back into context. Letters need to be shaped in relationship to each other, both inside and out. This

means that we need to take into account not only the letter shapes themselves but also the white space that surrounds them, i.e. the space within and between the letters.

Basic Shapes: Lowercase

When it comes to lowercase letters, we follow the same logic as with the capitals, with one difference: we are working with ascenders and descenders this time.

Again, we will identify "mother shapes" and take DNA from them to draw "sibling shapes."

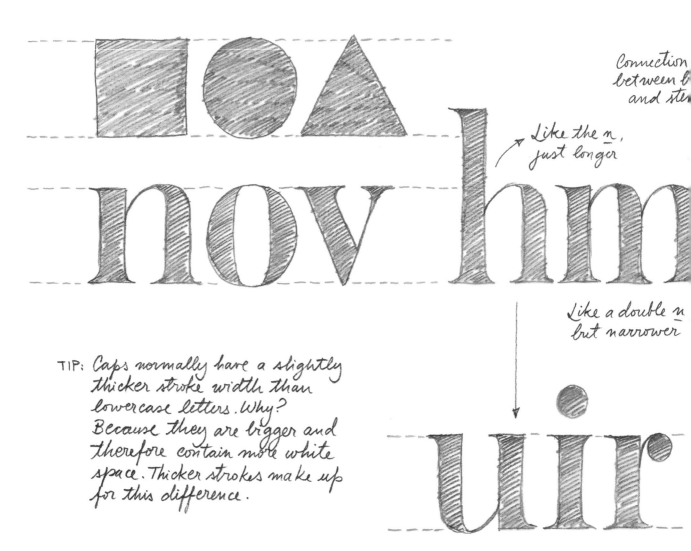

Connection
between l
and ste...

Like the n,
just longer

Like a double n
but narrower

TIP: Caps normally have a slightly thicker stroke width than lowercase letters. Why? Because they are bigger and therefore contain more white space. Thicker strokes make up for this difference.

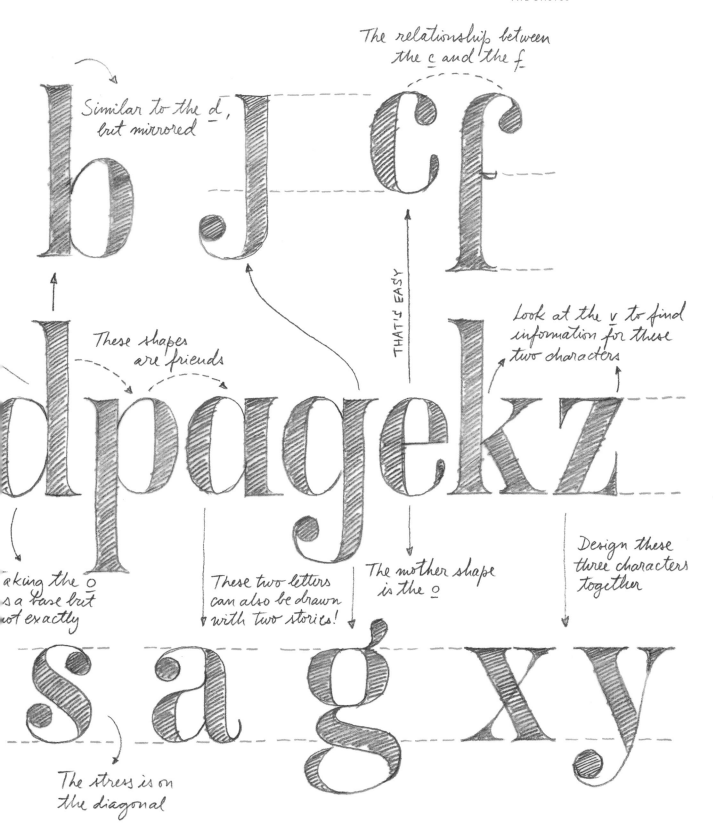

The relationship between
the c and the f

Similar to the d,
but mirrored

THAT'S EASY

These shapes
are friends

Look at the v to find
information for these
two characters

...aking the o
...s a base but
...ot exactly

These two letters
can also be drawn
with two stories!

The mother shape
is the o

Design these
three characters
together

The stress is on
the diagonal

Optical Adjustment

Reading about basic shapes and their geometry may make you think of math, but letter design has very little to do with that. Our work is not about numerical values so much as our own optical perception. This means that mathematical precision is not as relevant as optical adjustment: it must look good. Let's see how this works.

Take the three geometric shapes we have been examining, make them the same size, and place them on the same baseline. The shapes are geometrically the same width and height, but to our eyes the circle looks smaller than the square, and the triangle appears even smaller.

The reason for this discrepancy is that a square has a more direct relationship with the baseline and cap line than the other shapes because it touches them with an entire border, whereas only a small part of a circle or a triangle touches these lines.

To make the forms appear the same height, they require optical adjustments. The circle must be drawn a bit bigger and go slightly over the baseline and cap height. Similarly, the triangle must extend past the cap height in order to look as high as the other shapes.

If we translate this into letter shapes, our O and A will go beyond the guidelines, and this principle will extend to all the letters that share the same basic shape.

How much overshoot should you have? Simply as much as you need to make it look good, and this will vary according to the letter shapes you are working with. There is no formula; instead, you will rely on your most valuable tool: your eyes. This is the point where you can drop your ruler, because you won't need it at all!

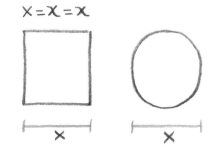

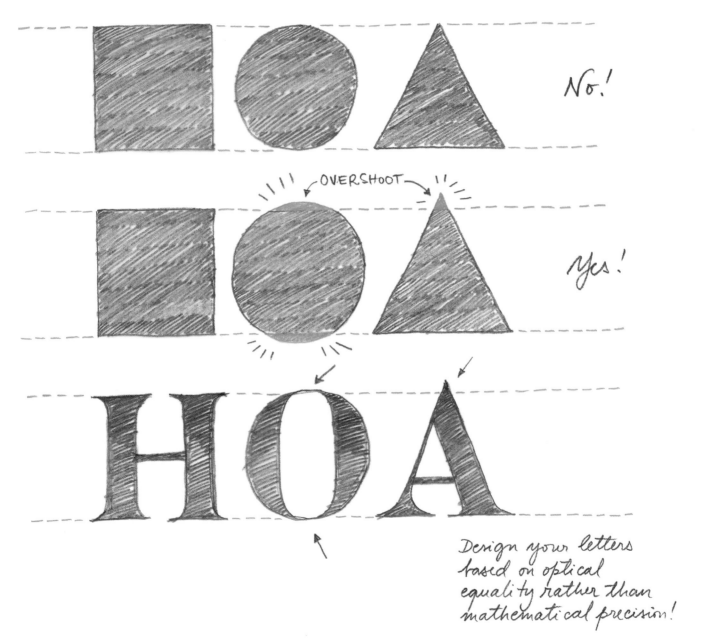

No!

OVERSHOOT

Yes!

Design your letters based on optical equality rather than mathematical precision!

The criteria for optical adjustment also apply to other design elements, such as the dot of the *i* or an exclamation point.

The dot, being a rounded shape, will need to have an overshoot in relation to the stem to appear to have the same width.

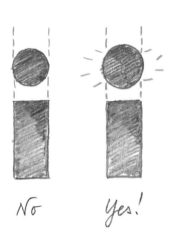

No Yes!

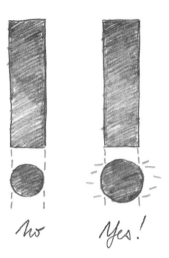

no Yes!

Similarly, a curve needs to have slightly more weight than a vertical stem in order to look optically balanced.

When is there enough overshoot? When it looks good!

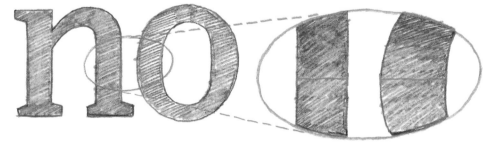

x < Y The rounded shapes are thicker

So although we are using geometric elements to draw our letter shapes, this is not a straightforward exercise. All of the elements require optical adjustments according to their position and use.

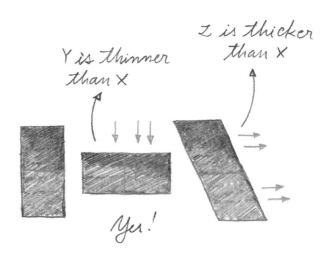

Y is thinner than X

Z is thicker than X

No

Yes!

Even when we are trying to make a shape look geometrically exact, we need to make optical adjustments to it. There is always a slight difference in stroke width.

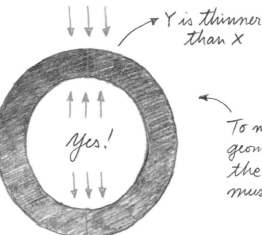

Y is thinner than X

No

Yes!

To make it look geometrically perfect, the stroke width must be adjusted

This O is supposed to look like a perfect ring

Spacing

The horizontal room between letters is called *spacing*.

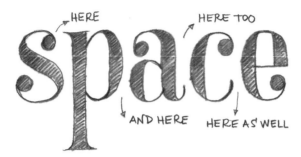

In letter design, spacing is as important as the letters themselves, because it allow us to identify where a letter starts and another begins, and it changes the perception of the letter or entire word itself. A word that is too loosely or too tightly spaced results in a change in its gray value and becomes less legible.

As a golden rule we can use the following formula to obtain optimal spacing:

$$\left\{ \frac{\text{Space within the letters}}{\text{Space between the letters}} \right.$$

If we could fill the space within a letter with water, we should be able to fit the same amount of water between that letter and the following one.

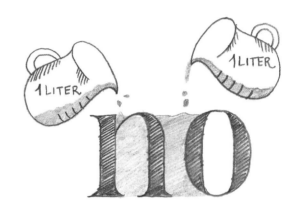

This rule makes it easy to find the optimal spacing for any kind of letter shape you create. If your letters are wide, their inner space will be big and you will therefore need lots of space between letters. On the other hand, if your letters are narrow, the amount of water that fits inside will be less and you will require less space between the letters.

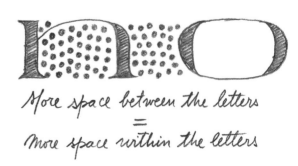

More space between the letters = more space within the letters

Less space within the letters
=
Less space between the letters

Other variables can influence this formula. For instance, if the lettering is displayed in a large size, it might need tighter spacing than if it is displayed in a small size. Your eyes will decide how much space you need to make the letters look right.

Spacing creates rhythm and keeps the words together; it is an essential part of the letterform. Thus, it is not something we decide afterward: rather, it is a fundamental part of the design process and needs to be designed in tandem with the letter shape.

The distance between two words is called *word space*. It too depends on the letter shapes and the space within them.

Line space is the distance between lines of text. Take note of ascenders and descenders here!

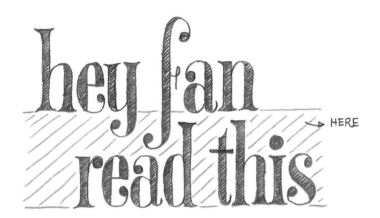

Tricky question: Where does the space within a letter end and where does the space between the letters start?

That is why we design the letter shape and the white space surrounding it at the same time!

Weight and Contrast

The weight of a letter describes the value of its strokes. It also has a direct relationship with its spacing, because the stroke width affects the amount of "water" (or white space) that fits within a letter and therefore also the space between that letter and the next.

When making a letter thicker, we can add weight consistently to all its strokes or we can apply weight inconsistently, which will lead to a change in contrast. Contrast is the difference between the thinnest and thickest parts of a letter. If there is little difference, the

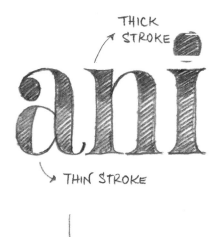

THICK STROKE

THIN STROKE

The smaller the difference is between thick and thin strokes, the lower the contrast is

The thin strokes were enlarged a lot here, whereas the thick strokes were thickened only slightly. This leads to reduced contrast.

HIGH CONTRAST

Add more substance to the thin strokes than to the thick ones

LOW CONTRAST

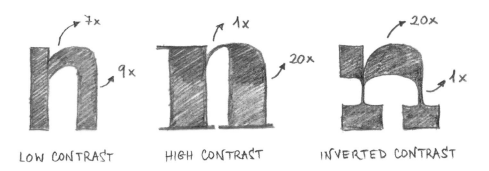

LOW CONTRAST HIGH CONTRAST INVERTED CONTRAST

letter's contrast is low. If there is a lot of difference, the contrast is high. How much contrast should your letters have? There is no formula for that either!

The horizontal strokes are thick (whereas they are normally thin)

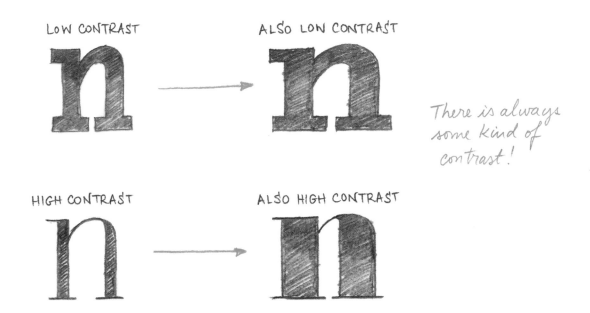

LOW CONTRAST ALSO LOW CONTRAST

There is always some kind of contrast!

HIGH CONTRAST ALSO HIGH CONTRAST

Numerals

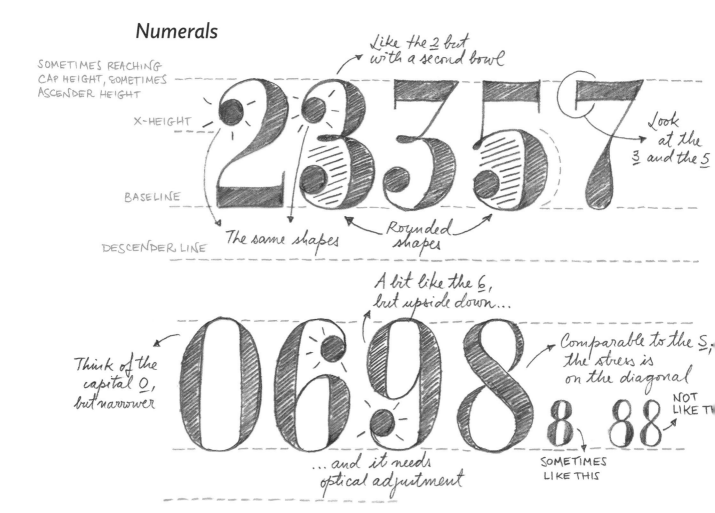

SOMETIMES REACHING CAP HEIGHT, SOMETIMES ASCENDER HEIGHT

X-HEIGHT

BASELINE

DESCENDER LINE

Like the 2 but with a second bowl

Look at the 3 and the 5

The same shapes

Rounded shapes

A bit like the 6, but upside down...

...and it needs optical adjustment

Think of the capital O, but narrower

Comparable to the 5, the stress is on the diagonal

SOMETIMES LIKE THIS

NOT LIKE T

It doesn't seem to be a lot of work at first sight, but...

There are variations here

OLD-STYLE FIGURES

no 1234567890

Figures designed especially to work with lowercase letters (they have ascenders and descenders)

LINING FIGURES

NO 1234567890

They work well next to capital letters

... and Punctuation Marks

Punctuation marks also have an overshoot!

Aligned with the capitals

PARENTHESIS

Bigger than the dot of the i

PERIOD

An extension of the period

COMMA

Aligned with the x-height

COLON

Colon and comma combined

SEMICOLON

Smaller than period

ELLIPSIS

Goes beyond the baseline

...t thinner than ...ular stroke width

Similar to a comma but smaller and upside down

QUOTATION MARKS

The asterisk has normally five or six points

ASTERISK

English and American"

«French and Spanish»

Aligned to the x-height

GUILLEMET

The use of quotation marks varies according to language

Normally aligned with the capitals

...eded for Spanish

QUESTION MARK

EXCLAMATION MARK

Look at the 8 for solving this one

Used for indicating a range of values (e.g., 1981–2016) or a direction between pairs of words (north–south)

HYPHENS

EN DASH

Used to indicate a break between parts of a sentence

EM DASH

Used at the end of a line to break a word and in multipart words (e.g., cost-effective) or phrasal adjectives (e.g., high-school grades)

Chapter 4
▷ Calligraphy
▷ Broad-nib and
 (pointed-nib calligraphy

+ exercises

▷ Other tools

BRUSH
PEN

4

Tools

and Their

Applications

Pens, brushes, and other tools

Calligraphy: The "Mother of All Letter Forms"

We live in an era when text reproduction is very inexpensive or even free. Books are therefore a commodity accessible to all of us. This was unimaginable in medieval times, when books and manuscripts were copied by hand by scribes. Because of the amount of time and effort every copy required, they were scarce and expensive, with only a few lucky (and wealthy) people having access to them.

The tool of choice for text reproduction at that time was calligraphy. Its influence is still apparent in the structure and shape of our letters today. Therefore, studying calligraphy and the calligraphic tools is helpful for every lettering designer. It will help you understand the shapes of our alphabet and find solutions for your own designs.

There are two main groups of calligraphic tools: broad-nib and pointed-nib tools. They differ in shape but also in flexibility. Broad nibs are flat and rigid, and the stroke width changes depending on the angle at which you use them. Pointed nibs, on the other hand, expand when you apply pressure, resulting in thicker strokes with increasing pressure. Angle and pressure are thus the two main characteristics that define the difference in the tools' performance.

Although describing each of the calligraphic tools and styles in detail goes beyond the scope of this book, we will look at some of the principles that rule each group. As you already know, calligraphy is not the same as lettering; however, understanding the "art of beautiful handwriting" will help you improve your lettering work. A smart lettering artist always has a set of calligraphic tools at hand.

Basic calligraphic tools and materials:

Fine paper. Don't use regular copy paper
but special paper suitable for calligraphic ink

Ruler and pencil for guidelines

Nib holder (with broad and pointed nibs)
or calligraphy pens

Calligraphic
ink

THESE ARE
INSERTED HERE

Calligraphic ink
is more viscous than
India ink.
It adheres better to
the nib and is
easier to control

POINTED NIBS
(flexible)

BROAD NIBS
(rigid)

Broad-nib Calligraphy

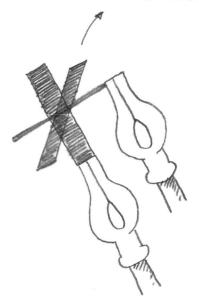

The stroke width depends on the direction of the movement as well as the angle at which the tool is held

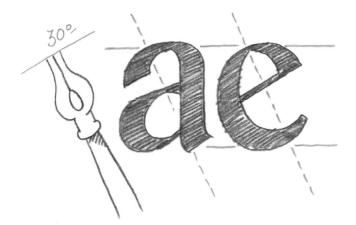

In broad-nib calligraphy the tool is moved downward and sideways in order to draw the letter shapes. It is held at a constant angle, so that the nib always points in the same direction. The unchanging angle is what makes the thick and thin strokes consistent. The most common angles are thirty and forty-five degrees. The hand moves from top to bottom and left to right while constant pressure is applied to the nib.

The proportion of the letters depends on the width of the pen nib in relation to the x-height and varies depending on style or script. To determine the width of the nib, hold the pen nib at a ninety-degree angle to the baseline, then pull it a short distance to the right to create a "block." This unit is used to define proportions in calligraphy. For example, in a certain style, the height of a capital letter might always equal six blocks, i.e., six nib widths.

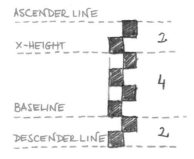

ASCENDER LINE
X-HEIGHT 2
 4
BASELINE
DESCENDER LINE 2

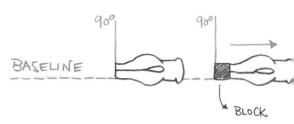

BASELINE 90° 90°
 BLOCK

Lettera Libero Happiness

*Broad-nib calligraphy
by Giuseppe Salerno*

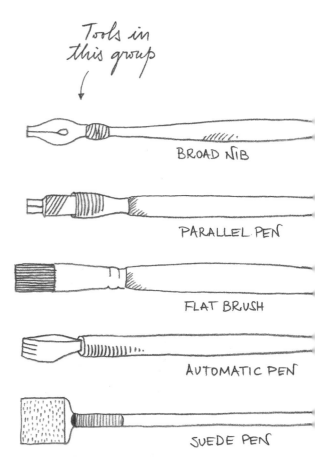

Tools in
this group

BROAD NIB

PARALLEL PEN

FLAT BRUSH

AUTOMATIC PEN

SUEDE PEN

You can use broad-nib calligraphy in many different ways. You can draw letter shapes that are rather controlled or geometric, or you can work with it freestyle, outlining more expressive strokes. The key is to stick to the rules of the tool throughout the whole process: keep the nib at a constant angle and pull it in the direction of writing.

Here is a basic exemplar for broad-nib calligraphy. Try following the order of the strokes and stick to the fixed angulation of broad-nib calligraphy. Take the pen and place it on the paper at a thirty-degree angle. Now move your whole arm and start writing.

Hold the pen nib at a constant angle of thirty degrees

Before you start, draw some guidelines

a a b c c d d e e
f g h h i j k k
l m m n n o o p p
q q r r s s t t u u v v
w w x x y y z z
1 2 3 4 5 6 7 8 9 0

For the letters v to z (and also for the k), hold the pen nib at a forty-five-degree angle

Do the same when writing the numerals

Broad-nib calligraphy
by Frank E. Blokland

Use a forty-five-degree
angle here as well

Pointed-nib Calligraphy

The stroke thickness
depends on the amount
of pressure that is
applied on the tool

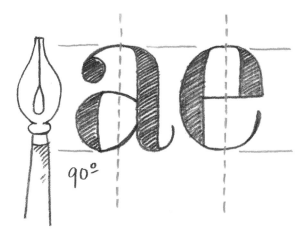

90°

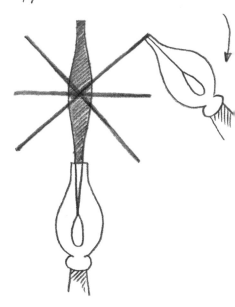

Pointed-nib tools work by pressure. When the hand holding the tool applies more pressure, the tip expands and more ink flows, creating a thick stroke. When the pressure is released, the nib contracts, resulting in a thinner stroke.

As a general rule, when we write with a pointed-nib tool, we apply pressure on the downstrokes (when we pull the tool downward) and release the pressure in the upstrokes (when we push the pen upward). The varying pressure is what determines the contrast of the letter shapes (the difference between the thinnest and thickest part of the letter). The amount of contrast is defined by the amount of pressure and by the relationship between the size of the letter and the nib.

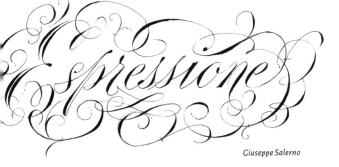

rafelranden van het schrift.

Elmo van Slingerland

Cinema

Giuseppe Salerno

Espressione

Giuseppe Salerno

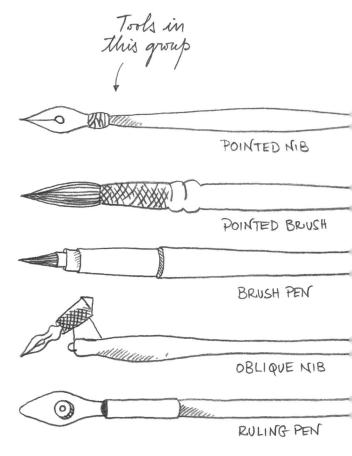

Tools in this group

POINTED NIB

POINTED BRUSH

BRUSH PEN

OBLIQUE NIB

RULING PEN

As with broad-nib calligraphy, we can use pointed-nib calligraphy for a variety of styles. There are moderate scripts as well as more expressive ones, but all are based on the same rule of achieving varying stroke width through varying pressure.

Here is a basic exemplar for pointed-nib calligraphy.
Try following the order and direction of the strokes
while sticking to the rule of applying varying pressure.
Take the pen and place it on the paper. Apply pressure
on the tool when pulling down; release pressure when
going up.

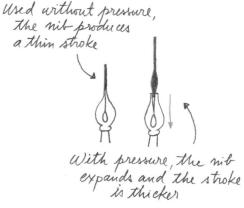

Used without pressure, the nib produces a thin stroke

With pressure, the nib expands and the stroke is thicker

Before you start, draw some guidelines. The closer together the lines are, the higher the contrast of the letters will be

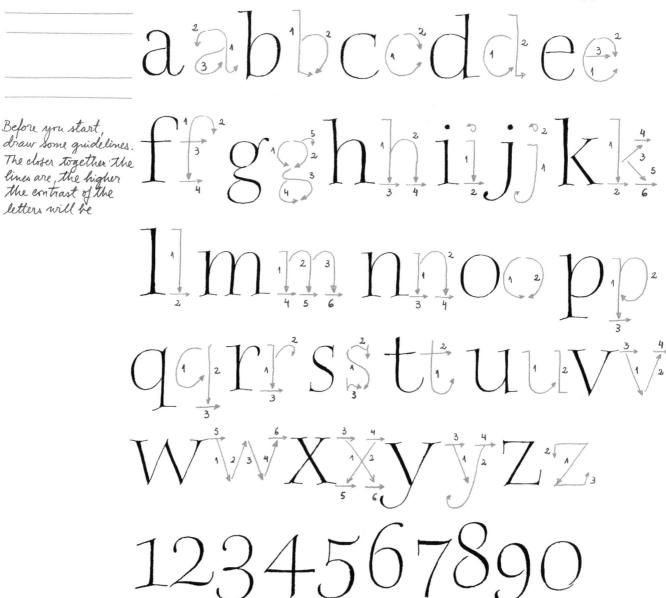

Pointed-nib calligraphy by
Elmo van Singerland

Flourishes and embellishments follow the same principle

Other Tools

There are many calligraphic tools, not all of which can be discussed here. But I want to encourage you to experiment with new writing tools. It will help improve your handwriting and train your typographic eye. When trying a new tool, you may take the following steps, shown here using one of my favorite tools as an example: the brush pen (a brush with a rechargeable cartridge).

The first thing to do when you are working with an unknown tool is to take a close look at it and study its features, so you can identify to which calligraphic group it belongs. Start by drawing some upstrokes, downstrokes, and circles to find out which principles the tool follows.

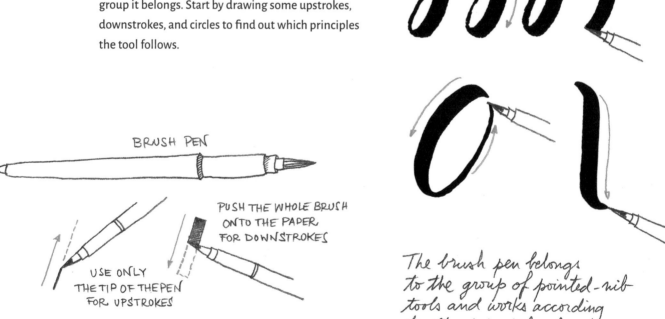

BRUSH PEN

USE ONLY
THE TIP OF THE PEN
FOR UPSTROKES

PUSH THE WHOLE BRUSH
ONTO THE PAPER
FOR DOWNSTROKES

The brush pen belongs
to the group of pointed-nib
tools and works according
to the principle of
varying pressure

Then look for a suitable exemplar and practice every individual letter.

a b c d e f
g h i j k l
m n o p q
r h s s t
u v w
x y z

Giuseppe Salerno

Once you have achieved good shapes, write whole words at different speeds.

Marittimo
Rispetto

Giuseppe Salerno

After a lot of practice you will become familiar enough with the script to be able to use it in a more or less freestyle manner. Remember that there are different styles for each tool, so do some research and find the ones you are interested in. The only key to getting better is:

Practice, practice, practice!

Mastering the basics of calligraphy is the foundation for drawing well-shaped letter forms. But how closely should we follow calligraphic principles when drawing letter shapes? This is something you will find out by doing. A golden rule is that it "should work." But how do you know if it works? With experience!

I encourage you to further your knowledge of calligraphy: take a course or workshop; read books about it; experiment with the tools on your own. You do not need to become a calligraphy master to do hand lettering, but having some calligraphic skills will certainly be a valuable starting point.

Chapter 5

▸ Exploring the design universe
▸ Letter shapes and Lettering styles

AND SHADOWS!

M SERIF LETTERING

S SANS SERIF LETTERING

R DIMENSIONAL LETTERS

Script lettering

n BRUSH LETTERING

n BLACKLETTER

F FUNKY LETTERING

D DECORATIVE LETTERING

5

The Lettering Designer's

PLAYGROUND

An overview of lettering styles

Exploring the Design Universe

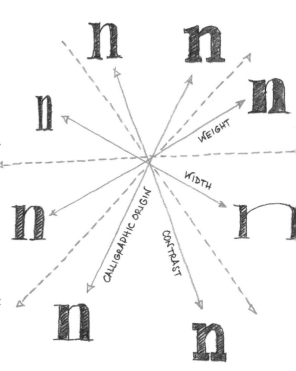

Our playground as lettering designers consists of every possible way of drawing a letter. It is, therefore, endless. We call it our design universe, and this is where we are at home.

The design universe is defined by parameters that operate between two poles. This means that when we work on, for instance, the weight of a certain letter shape, our room of exploration is found in between the thickest letter imaginable and its opposite, the thinnest letter we can imagine. But what is the thickest letter in the world? And what is the thinnest? There are no rules or limits here, for the possibilities in the lettering universe are endless!

There are a few parameters that we will work with quite regularly. These include contrast (the difference between the thinnest and thickest parts of a letter) and width (how wide or narrow a letter is). Serifs are another element we will deal with often: How many different shapes of serifs can we come up with? How sharp, rounded, or straight can they be?

Of course, these are not the only elements you can play with when drawing letters; you can experiment with as many as you like, no matter how unusual they are.

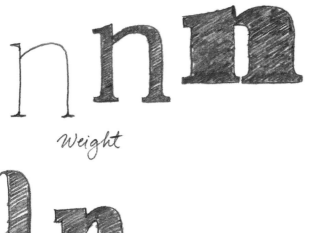

Weight

Contrast

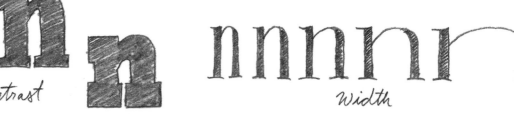

width

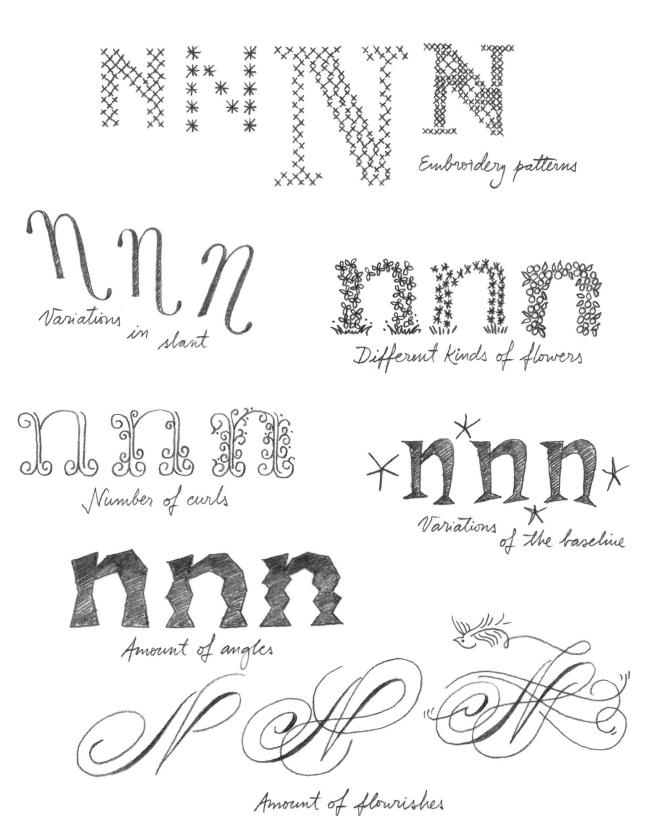

Embroidery patterns

Variations in slant

Different kinds of flowers

Number of curls

Variations of the baseline

Amount of angles

Amount of flourishes

Number of segments

Amount of leaves

Number of cuts

Amount of lines

Number of pixels

Shape of the stems

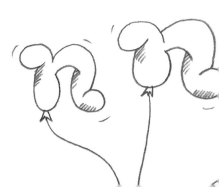

Width of the nib

Sharpness of the edges, or "speed"

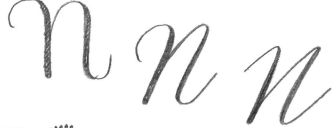

Number of points

Size of the serifs

Type of construction

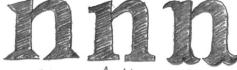

Shape of the serifs

Level of inflation

Length of the shadows

and so on...

Letter Shapes and Lettering Styles

How do we find the shape of a letter? There are no instruction manuals that will tell you what a serif should look like, or how wide the letter *a* or *n* should be. If I told you, for example, that a *B* should be drawn in a certain way, I would reduce the lettering universe to the options that my mind can imagine and my hand execute. My goal with this book is exactly the opposite, however: I want to hand you the tools and concepts that will enable you to develop your own personal lettering shapes and styles.

Nevertheless, in this playground, as in any other, we play according to some rules. One thing is predetermined in the lettering universe: the overall shapes of the letters of our alphabet. Our written language is nothing more than a convention in which we all agree that a certain form stands for a certain vocal sound. This form is the skeleton of the letter, and although we can explore this skeleton to its extremes (even to the edges of abstraction), certain features need to remain recognizable so that the letter can be distinguished

from other letters in the alphabet. A good example for this is our handwriting, which is based on a certain model but is still unique to every person, with a varying degree of legibility.

The restrictions for the shape a letter can take are defined both by the characteristic features of its skeleton and by the context in which it appears. The letter *M*, for instance, has to be recognized as an *M* in comparison to the letters surrounding it to not be confused with other letters.

Legibility is a fundamental part of lettering design, and the challenge of a hand letterer is to develop unique shapes without failing the main mission of our craft: conveying a message. If legibility suffers, our lettering may fall into the marshy waters of abstract art.

Within the boundaries of the basic shapes that we recognize as letters, the possibilities for drawing letterforms are endless. Even the basic shapes can vary for some letters (e.g., the lowercase *a* can take a one-story or two-story shape). Take some time to explore the infinite variations of the lettering universe. Experimenting with forms and styles is fundamental for developing your own style.

The moment we start speaking about styles, we reduce our scope to those we can name and ignore the variety of styles unknown to us or those still to be developed. However, there are of course a number of recurrent styles within the art of lettering. In the following pages I will introduce you to some of them and encourage you to explore further those you are interested in.

Rather than providing templates that you can copy, I will focus on the criteria behind each style so you can apply them in your own work.

Serif Lettering

An (arbitrary) selection

Serifs are thought to play a role in the legibility of bodies of text set at small sizes, but in lettering their use is less functional than aesthetic. Therefore, the variety of serifs in lettering tends to be larger and wilder than that of type. For our purposes we will call all letter shapes that have a terminal to the strokes, whatever it looks like, *serif* lettering.

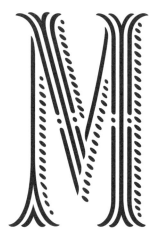

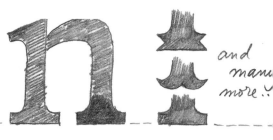

TRANSITIONAL, OR OLD STYLE

and many more!

These shapes have their origin in broad-nib calligraphy

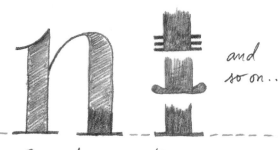

MODERN, OR DIDONE

and so on...

Based on pointed-nib calligraphy. Note the thin serif

This spread shows some of the most common serif styles as a foundation for some more uncommon, exciting variations. This doesn't imply that the variants historically developed like this but is meant to encourage you to take these basic forms as inspiration to develop your own ideas.

Are there other shapes for serifs?

Of course!

SLAB SERIFS

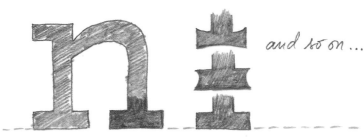

and so on...

Similar shapes to those of modern or Didone, but the serifs are blown up

GLYPHIC SERIFS

And whatever other variations you can come up with...

Triangular serif shapes and various kinds of horizontally extended stroke endings

Another (arbitrary) selection

Sans Serif Lettering

This group is hard to define, because no letter shape is completely free of serifs. However, for our purposes we will call *sans serif* all letter shapes that have straight, clean-cut terminals, without additional shapes extending the stroke width boundaries.

GROTESQUE

The most popular form of sans serif letters, often with low contrast

HUMANISTIC

The calligraphic variation of a sans serif. Often the ductus is visible in the stroke

In lettering we can play around with these boundaries—just as a serif can be really extroverted, a sans serif can also get quite extreme but still belong to the category of sans serif letters.

How many variations of sans serifs are there? As many as you can come up with: after all, the stroke endings have to be designed somehow. No shape is completely serif-free

SQUARE

Based on Grotesque forms but with angular curves

not really geometrical but supposed to appear geometrical

GEOMETRICAL

The letters are developed from geometric shapes

Dimensional Letters and Shadows

A three-dimensional letter shape can be drawn with or without perspective. In the first case, the farther away the edge of the letter is supposed to be, the smaller it needs to be drawn. For a letter without perspective it is sufficient to repeat the same shape slightly offset and join the points.

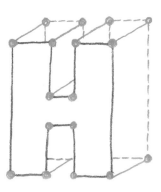

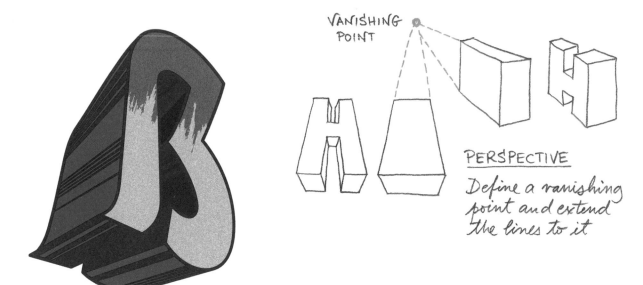

VANISHING POINT

PERSPECTIVE
Define a vanishing point and extend the lines to it

AXONOMETRIC PROJECTION
Repeat the shape and join the points

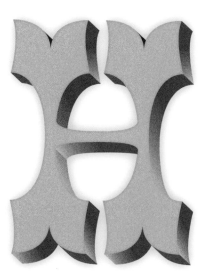

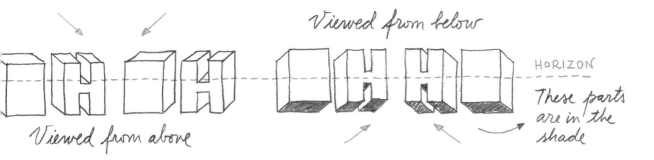

Viewed from below

Viewed from above

HORIZON

These parts are in the shade

...hree-dimensional letters often come along with ...hadow effects. For where there is volume and lighting, ...here will be shadows. The key to adding shadows to your lettering is to determine where the light source is coming from and to apply it consistently on all letters. The effect differs depending on the location of the light source.

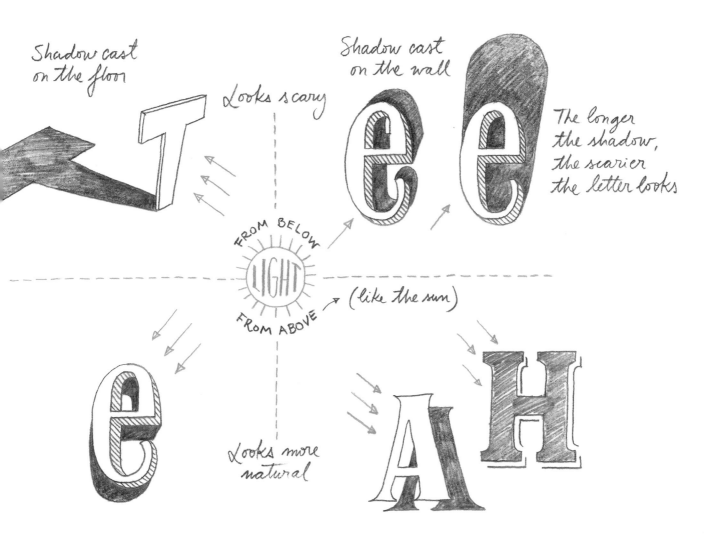

Shadow cast on the floor

Looks scary

Shadow cast on the wall

The longer the shadow, the scarier the letter looks

FROM BELOW

LIGHT

FROM ABOVE → (like the sun)

Looks more natural

Script Lettering

Wonderful

Script lettering (also known as *cursive*) is the umbrella term we use for all styles with letterforms that are joined together by a continuous movement, as in cursive handwriting. The easy flow of letters that are connected to each other is a way of accelerating the writing.

There are as many cursive handwriting styles as hands in the world; however, they are all based on cursive handwriting models acquired at school or elsewhere. The variation occurs when each hand leaves its own imprint when executing the shapes.

Although nowadays handwriting styles tend to look increasingly similar, their main features vary according to country. In French cursive handwriting, for instance, letters tend to be rounded and upright.

French

Throughout North, Central, and South America, handwriting models are based on narrower letter shapes with a slanted axis.

Handwriting

Although no longer in use, Sütterlin script was once widespread in Germany. Today many of the Sütterlin letter shapes are illegible even to German speakers.

Sütterlin

↳ *This means Sütterlin*

ript lettering
as lots of
fun flourishes!

Script lettering is ruled by similar principles as handwriting: slant, width, speed, and rhythm.

Hand | Hand / Hand / Hand

The *slant* refers to the incline of the letters. We call them upright when the axis reaches ninety degrees. Most scripts slant in the direction of writing, but there are also some with a back slant, with letters leaning in the opposite direction.

Hand Hand Hand

The *width* refers to how wide the letters are in the horizontal axis, both regarding the letters themselves and the space between them.

Relaxed Nervous

Speed is a distinctive feature of cursive lettering. Handwriting created at low speed tends to be wider, with a regular baseline. Handwriting performed by a nervous hand tends to be narrower, with an irregular baseline. Script lettering picks up these characteristics depending on style.

Formal

The *rhythm* is determined by all previous features and describes the level of regularity and consistency in the letter shapes.

Because brush lettering is based on writing by hand with a brush, it has lots of form variations for a single letter *aaaaa*

Sweet and cute

MAIN CHARACTERISTICS:
— Soft stroke endings
— Gracious shapes
— Variable width depending on the speed of writing

CHARACTERISTIC STROKE ENDINGS

Remember how the pointed brush works?

Use the tip when you go up

Push the brush against the paper when you go down

Brush Lettering

Brush lettering is based on calligraphy executed with a pointed nib or pointed brush. It is a form of script lettering and follows the same principles, as can be seen in the wide variety of shapes and the influence of speed on letterforms. The strokes tend to be irregular, and the stroke endings are often soft and rounded, corresponding to the end of a brush.

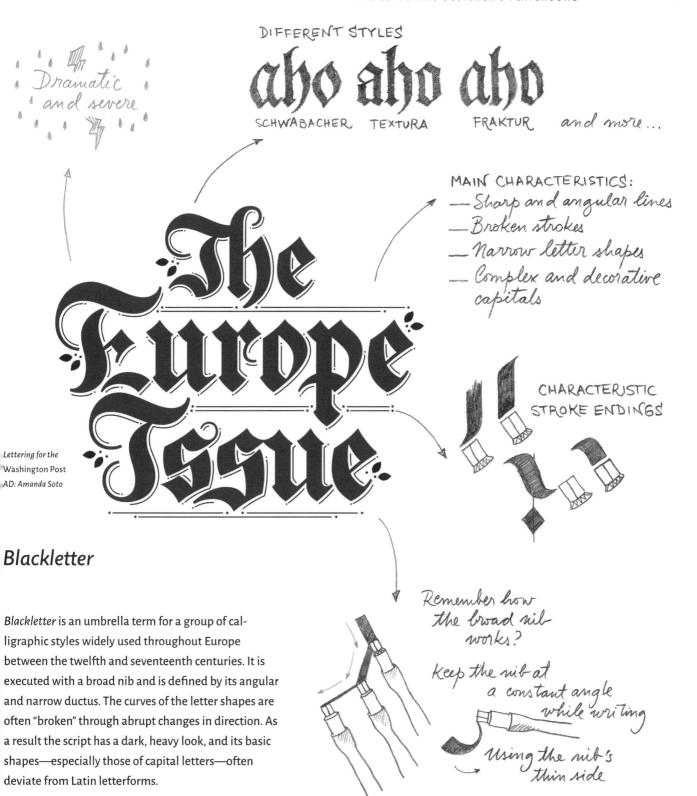

Dramatic and severe

DIFFERENT STYLES

aho aho aho

SCHWABACHER TEXTURA FRAKTUR *and more...*

MAIN CHARACTERISTICS:
— Sharp and angular lines
— Broken strokes
— Narrow letter shapes
— Complex and decorative capitals

The Europe Issue

Lettering for the Washington Post
AD: Amanda Soto

CHARACTERISTIC STROKE ENDINGS

Remember how the broad nib works?

Keep the nib at a constant angle while writing

Using the nib's thin side

Blackletter

Blackletter is an umbrella term for a group of calligraphic styles widely used throughout Europe between the twelfth and seventeenth centuries. It is executed with a broad nib and is defined by its angular and narrow ductus. The curves of the letter shapes are often "broken" through abrupt changes in direction. As a result the script has a dark, heavy look, and its basic shapes—especially those of capital letters—often deviate from Latin letterforms.

Funky Lettering

A nice way of saying "crazy"

This is an unofficial term for letter shapes that look "funny," most often due to uneven proportions or an uneven baseline and x-height. Depending on how extreme these features are, "funky letters" may turn into "monster letters."

LETTER PROPORTIONS

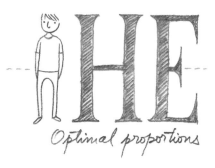

Optimal proportions

Short upper part of the body, long legs

Long upper part of the body, short legs

and so on...

Funky lettering can turn into monster lettering

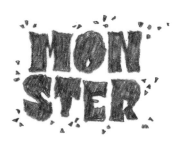

Irregular baseline

You can also alter other features of letter shapes in an extreme way to achieve funky lettering. As with all lettering styles, the boundaries are vague. A common method of creating funky lettering is to reverse the contrast, i.e., turn the thin parts of a letter into thick parts and vice versa. Increasing the size of the serifs is another technique. Often the result is reminiscent of circus posters or has connotations of the Wild West.

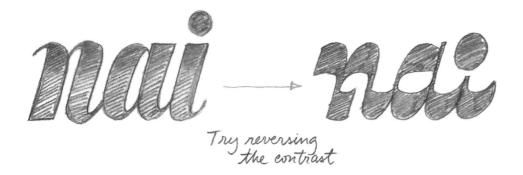

Try reversing the contrast

TIP:
The more contrast, the funkier the effect

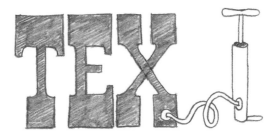

Try inflating the serifs

Decorative Lettering

Like a wedding cake, this lettering style consists of
several layers of decorative elements that are piled on
top of each other. Ideally, these elements are planned
beforehand as an essential part of the design and are
not add-ons that are applied to the letter shapes
afterward. The use of color and contrast are important
elements of decorative lettering.

*Decorative lettering
is often used for
individual letters
or initials*

OUTLINE DECORATION

INTRICATE
LINE WORK

3-D WITH LOTS
OF LOVE FOR DETAIL

Decorative lettering can also become more abstract,
resembling an illustration. You can create letter shapes
out of a ribbon, for instance, or another real object.
Here the nature of the object used to construct the
letter has a great influence on its resulting shape.

*Use a real ribbon
as a model!*

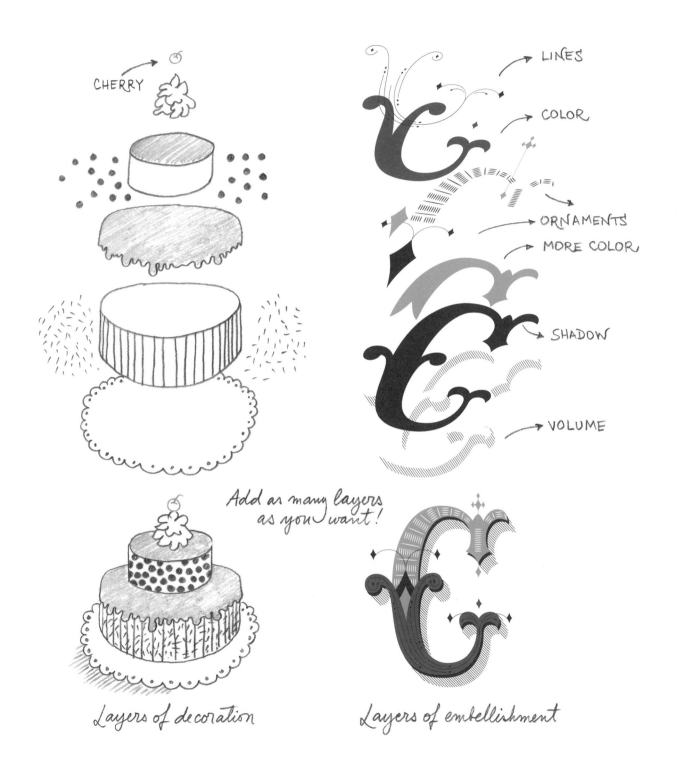

CHERRY

LINES

COLOR

ORNAMENTS

MORE COLOR

SHADOW

VOLUME

Add as many layers as you want!

Layers of decoration

Layers of embellishment

Building Your Own Lettering Library

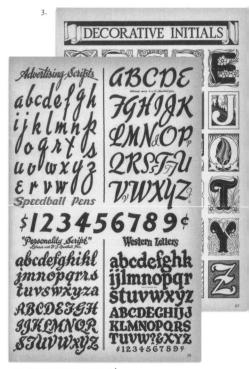

The same way a painter studies artistic movements, a lettering artist should be aware of the different styles in the history of lettering. Just like artworks, letters too are shaped by the historic context in which they appear. Developments in technology and production techniques also influence letterforms. For example, the invention of lithography opened up a range of new possibilities that were impossible when printing with movable type.

Knowing and studying what others did in the past helps us understand our position in the craft of lettering and think about what our own contribution to it can be.

TYPE SPECIMENS

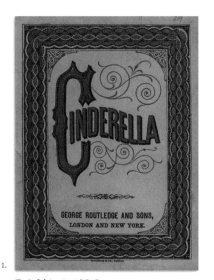

1.
BOOK COVER

2.
VINTAGE
PACKAGING DESIGN

Take the time to study the various historical models, to analyze them, and to practice them. This will help you grasp the scope of creative possibilities and improve and expand your lettering skills. Exploring a variety of lettering styles will help you develop your own style and solve issues when designing your own pieces.

Read books on calligraphy and study calligraphic exemplars. Photograph or collect vintage typographic samples on postcards, posters, or packaging. Slowly build your own library of inspiration.

4.

STAMPS

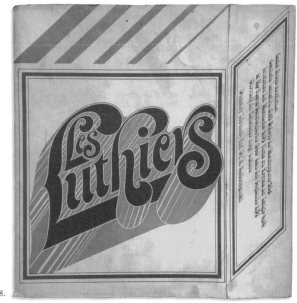

8.

RECORD COVER

5.

MAGAZINE COVER

9.

EPHEMERA

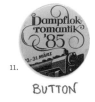

11.

BUTTON

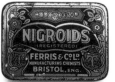

12.

DECORATIVE TINS

DOCUMENTS

6.

7.

BOOK COVER

10.

DRY-TRANSFER
LETTERING SHEETS

13.

WOODBLOCK
TYPE

1. Cinderella by George Routledge
 and Son. Book cover
2. Packaging for nibs
3. Old type specimens
4. Rubber stamps by Sol Matas
5. The Magazine of Art. Cover
6. Argentinean savings book
7. Große Erfinder und Entdecker.
 Book cover
8. Les Luthiers. Record cover by
 Ricardo Rousselot
9. Vintage ephemera
10. Dry-transfer lettering sheet
 by Letraset
11. "Dampflok-Romantik" (steam
 engine nostalgic) button, 1985
12. Nigroids tin
13. Woodblock type

D'après Walter Eaton de Londres

Jules Girault script et sculp.

Chapter 6

- HIERARCHY AND structure

- Distortion

- ▸ Flourishes and swash letters

 Curls

- ▸ Ornamentation

 ARROWS ⟶ ⟶ FRAMES

 ♡ ♡ ♡ HEARTS

 and more...

- ▸ Thumbnails

6

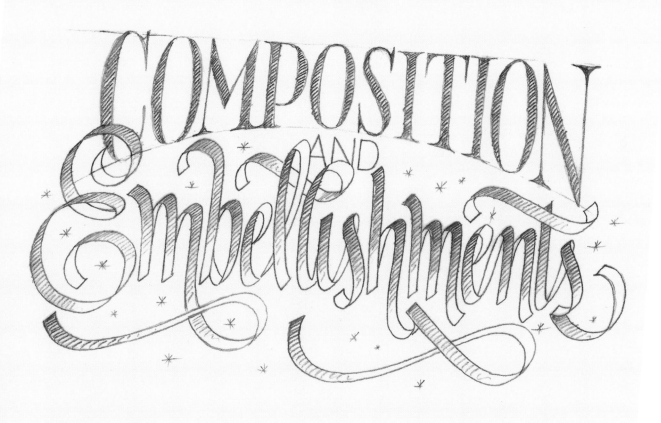

COMPOSITION AND Embellishments

Structure, hierarchy, and flourishes

Hierarchy and Structure

In some cases lettering is used to play a supporting role in a design, appearing, for instance, in the tagline for a logotype. In those cases, your lettering will have to adapt to the preexisting elements.

More often, however, lettering is the star of the design and needs to be able to stand on its own. This means that we have to develop a structure for the words or sentences we draw. The structure is the skeleton on which the words will sit. To design it, we first need to establish hierarchies in the text. The way you organize the elements will help the reader quickly identify what is important and what is secondary.

We can create different levels of hierarchy in a number of ways. The most common and easiest one is size: Large words come to the front, while smaller ones recede to the back.

We can also establish hierarchy through color by using brighter colors for the elements we want to highlight and lighter tones for those that are less important. Embellishments can also help us make a certain word or part more prominent by enhancing its appearance. Weight is another way of emphasizing parts of the text by making certain words bolder.

Finally, another common way of defining hierarchies is by combining different styles of lettering; for instance, using serif lettering together with an English script. This way we develop two groups of content within the composition. Of course, we can also combine the various ways of establishing hierarchies.

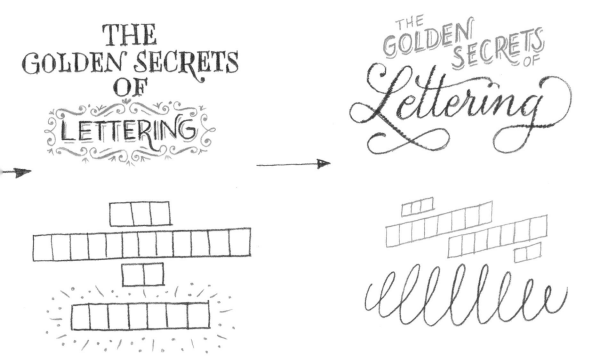

Establishing hierarchies is the first step in defining the
structure of a composition. In the process, we organize
the elements we will be working with. The next step is
deciding the position of these elements, which is also
determined by hierarchy.

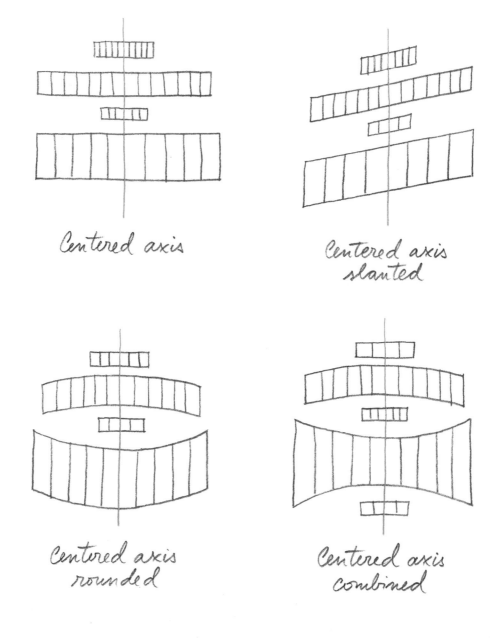

Centered axis

Centered axis
slanted

Centered axis
rounded

Centered axis
combined

We can use a centered composition, with all words
aligning to a centered vertical axis. We can also align
the elements to the left or the right.

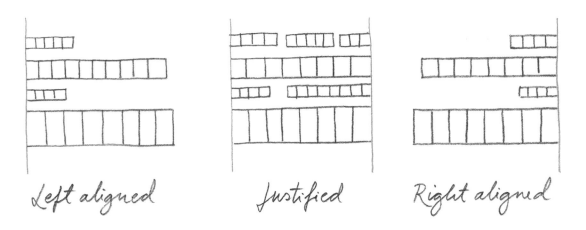

Left aligned Justified Right aligned

Or we can use a justified composition and make all text
fit a certain format; for instance, a circle or a square.

Our compositions may also become more complex and
include several axes and shapes. Experiment with other
combinations and take it as far as you wish!

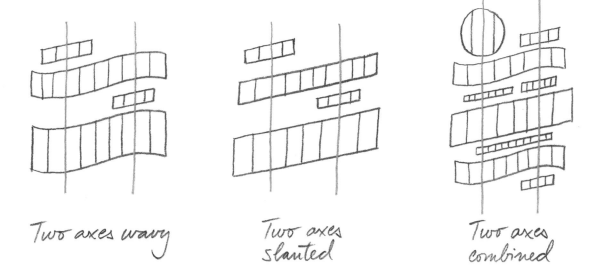

Two axes wavy Two axes slanted Two axes combined

Distortion

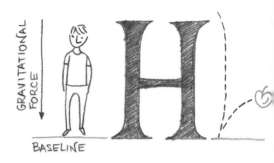

An exciting characteristic of lettering is its capability to adapt to various surroundings or formats.

As a principle, letter shapes follow the law of gravity. Therefore, when you are working with distorted formats, the letter shapes should still maintain their balance and center of gravity within the distorted format.

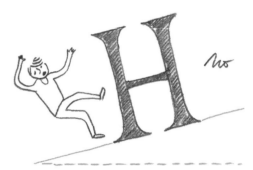

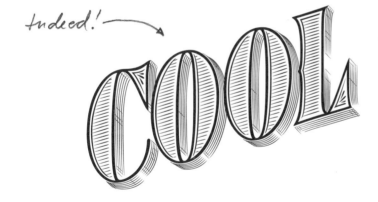

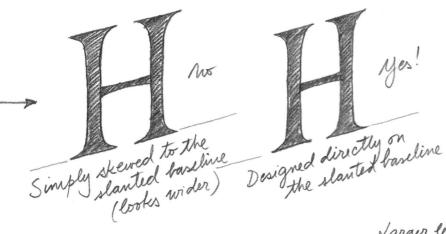

no

Yes!

Simply skewed to the slanted baseline (looks wider)

Designed directly on the slanted baseline

When you use a text container, make sure to draw the letters directly into the shape. Distorting them later using software would lead to letterforms that look unbalanced and strange.

Adjusting the letters to a specific shape will lead to different x-heights and a changing baseline within a single word. In order to keep the gray value of the word consistent, you will need to make optical adjustments. Once again your typographic eye will help you achieve a balanced composition.

Larger letters have more white space, which requires optical adjustment

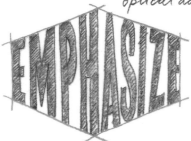

Smaller letters look lighter than larger ones and need optical adjustment

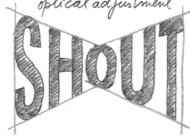

Create a grid of guidelines to help you distort all strokes consistently

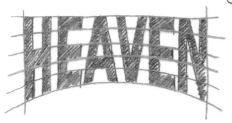

Flourishes and Swash Letters

Flourishes and other embellishments are some of the most attractive aspects of lettering. If you are taking your first steps in the field of hand lettering, you will very likely be tempted to use many flourishes in your designs, but even though they can contribute much, less is often more! Bear in mind a few basic rules when adding embellishments.

Flourishes can be useful to create balance in a composition.

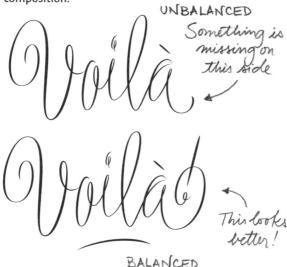

They can also highlight a certain part of the text.

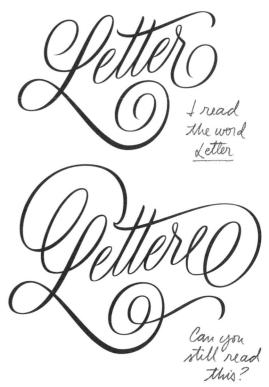

Keep in mind that flourishes create positive and negative space and thus influence the distance between letters. Swashes can also easily produce shapes that resemble a letter and affect the legibility of the overall text.

The nature and shape of flourishes should fit the lettering style you are working with. The embellishments used in blackletter, for example, are rather different from those in brush lettering. Explore old calligraphy and lettering manuals to discover the particularities of each style.

lourishes are extensions of the letter shapes, and herefore, the letters themselves will guide us in reating embellishments that suit those letters. The ontrast and weight of our flourishes will correspond to

the contrast and weight of our letters (and the calligraphic model they are based on). The "mother shapes" ruling our letters will also determine the forms of the flourishes.

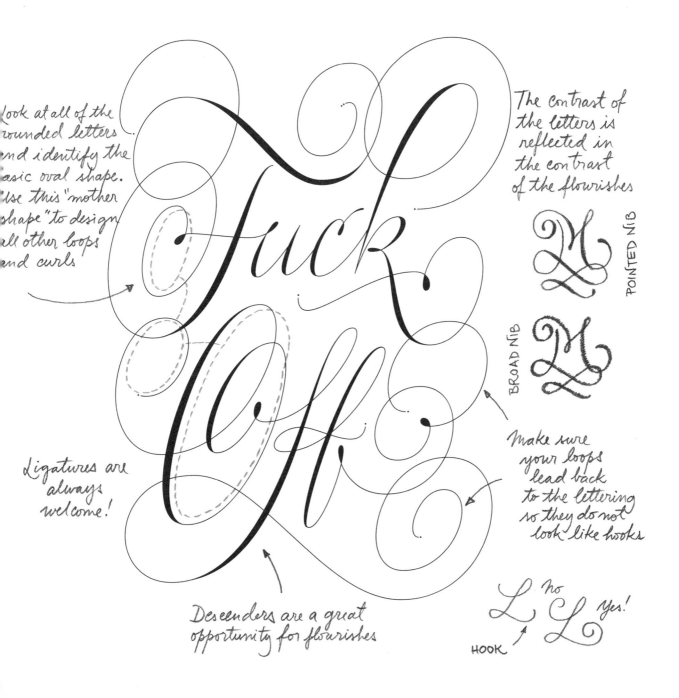

look at all of the rounded letters and identify the basic oval shape. Use this "mother shape" to design all other loops and curls

The contrast of the letters is reflected in the contrast of the flourishes

POINTED NIB

BROAD NIB

Make sure your loops lead back to the lettering so they do not look like hooks

Ligatures are always welcome!

Descenders are a great opportunity for flourishes

HOOK

no

Yes!

Basic Flourishes

As mentioned previously, most lettering and calligraphic styles come accompanied by a specific set of shapes for flourishes. This book takes a contemporary approach to lettering; while I acknowledge the existence of past models, I do not advocate simply reproducing them.

Getting to know the historic models will certainly help you develop your expertise about lettering, but you should feel free to step away from the traditional forms and find your own way.

Even the most intricate flourishing can be broken down into simple shapes. Your job will be to combine these elements in an innovative and interesting way.

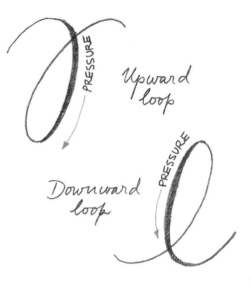

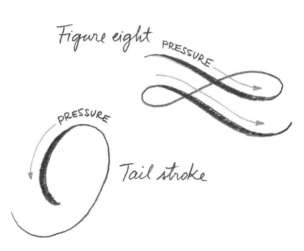

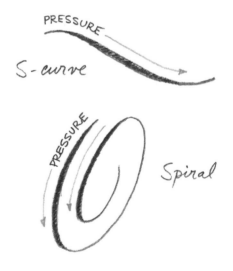

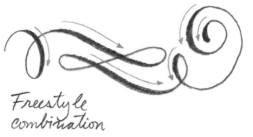

Flourishes can be used for various purposes; some of the most common include borders, patterns, initials, frames, and text embellishments. Calligraphic strokes are not the only elements you can use to create your own flourishes. Try experimenting with floral patterns, ivy, or whatever else fits your letter shapes.

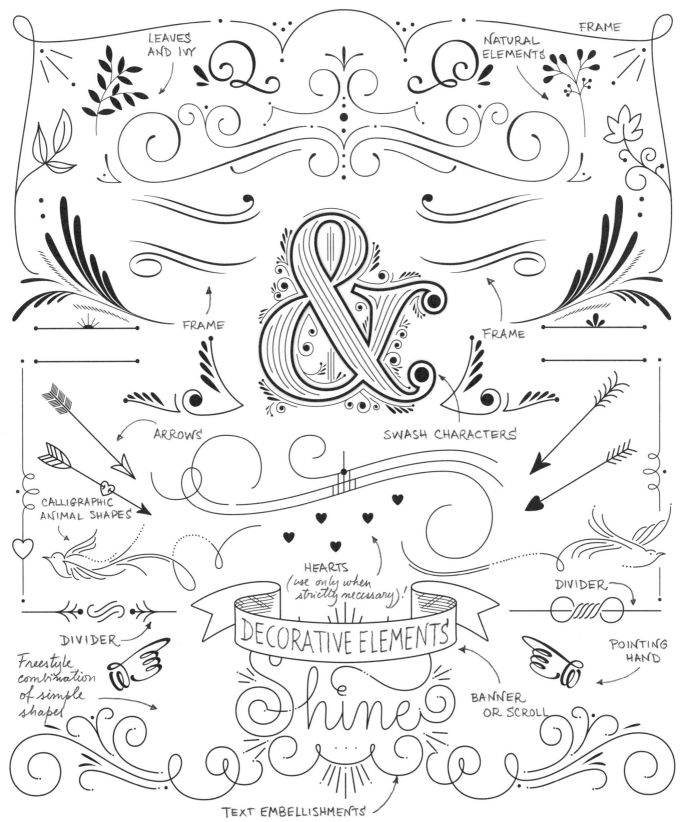

LEAVES AND IVY

NATURAL ELEMENTS

FRAME

FRAME

FRAME

&

ARROWS

SWASH CHARACTERS

CALLIGRAPHIC ANIMAL SHAPES

HEARTS
(use only when strictly necessary)!

DIVIDER

DIVIDER

Freestyle combination of simple shapes

POINTING HAND

DECORATIVE ELEMENTS

Shine

BANNER OR SCROLL

TEXT EMBELLISHMENTS

THE
Golden
Secrets
OF
Lettering

THE
GOLDEN SECRETS
OF
Lettering

THE
GOLDEN SECRETS
OF
Lettering

THE
GOLDEN
SECRETS
OF
Lettering

The
Golden
Secrets
of
Lettering

THE GOLDEN
OF SECRETS
Lettering

THE
GOLDEN SECRETS
OF
Lettering

THE
GOLDEN SECRETS
OF
Lettering

Thumbnails

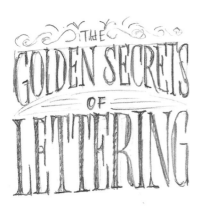

I typically start a project by establishing hierarchies and structure, as this determines the way the lettering will occupy the space. For this purpose I make lots of small pencil sketches, around two to three inches (five to eight centimeters) wide, in which I play around with blocks of content. At this point I can also already explore first ideas about the lettering style of the piece.

The great thing about working at such a small size is that you can focus on the big picture instead of digging deep into details too early. You can quickly try out different structures and combinations and see what works best.

After establishing a structure that fits your project, you can either draw a larger-scale version of the sketch or scale it up using a copy machine. This enlarged version will serve as a basis for the next steps.

This will be the starting point for my sketches

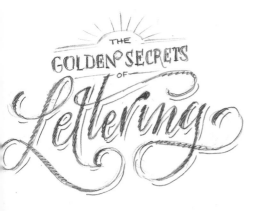

Chapter 7

SKETCH → Sketching

↘ Tips for beginners

↳ Basic tools and supplies

▸ Working with layers

```
   ┌──────────┐
  ┌┴─────────┐│
 ┌┴─────────┐││   ↑
3│          │││
2│          ├┘│
1│          ├─┘
 └──────────┘
```

↳ The sketching process at a glance

Sketching

LETTERFORMS

From rough sketch
to refined drawing

(and some helpful tips and tricks)

Basic Tools
and Supplies

Drawing letters is not about getting everything right in
the first sketch. On the contrary, it is an iterative
process: in each step we make decisions, change details,
and refine shapes. Therefore, it is important to use a
technique that facilitates iterations and allows us to
work comfortably.

My favorite method for sketching is working with layers
of drawings on tracing paper. This technique enables
you to work on improving your sketch on each new layer
without losing the results of your previous attempts. To
use this method, you need white paper, plenty of
tracing paper, and a pencil (preferably a mechanical
pencil so you don't have to sharpen it all the time).

PAPER *Regular copy paper is just fine*

Some "forbidden" items are rulers and graph paper.
Sticking to geometric measurements will only hinder
you from drawing the shapes as you want them to be. I
also recommend against using a notebook, since the
pressure of turning it into a pretty object hampers the
process of trial and error. Loose paper works better for
our purposes.

What you do not need:

SKETCHBOOK

If you use a sketchbook you may feel pressure to create something "permanent." It's better to use loose paper

TRACING PAPER

Forty grams is the ideal weight but others work as well. Buy it in a roll, so you can decide upon the size of the drawing

MEASURING TOOLS

Using these will lead you to draw according to the tools' parameters rather than your own ideas

MECHANICAL PENCIL

This one you don't need to sharpen all the time

PENCIL

SHARPENER

Sketching

You have already made some thumbnail sketches to define hierarchies and structure. Perhaps you have even come up with some style directions for your letters. The next step will be to explore your concept in a larger size.

When you start sketching, do not to try to make a pretty or perfect drawing right away. Do not worry if your strokes are a bit rough and stiff at the beginning. Your hand will become looser with time, and your sketch will become more accurate and refined with each step of the process.

Create your first draft on white paper. Sketch relatively fast and with a low amount of detail. Your drawing should be a suitable size: big enough to add details later on and small enough to not take too long to finish. A letter-size piece of paper (or DIN-A4) usually does the job for me.

Make sure to focus not only on drawing outlines but also filling your shapes. This will enable you to see how heavy or light each letter is and whether it works well with the other letters.

Try different solutions for a single character

Draw words rather than individual letters

Your first sketches need to be rough!

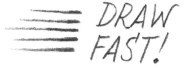
DRAW FAST!

Don't focus too much on one letter. Keep an eye on the whole picture

Be disrespectful with your drawing. Change the things that you don't like

Sketch decorative elements too!

FTCH

Your drawing should be neither too large nor too small. Letter size works well

Keep an eye on the spacing

Don't work only with outlines; make sure to fill the shapes

no. K K. Yes!

Hey, relax your hand!

Tips for Beginners

Living as we are in the digital era, we are no longer used to working with our hands. For this reason, you may require a lot of practice to become effective at sketching. But believe me, no matter how awkward it feels at first, you will get the hang of it at some point.

A common mistake that many beginners make when working on their first sketches is to fall in love with the first letter that looks more or less decent. Suddenly it does not matter whether that *n* works in combination with the other letters in the word—you spent so much time drawing the letter, it's hard to let it go.

My advice to avoid this pitfall is to work fast. Sketch as quickly as you can and don't waste time trying to make a letter look "perfect." This is not what these first drawings are about.

Sketching fast will enable you to keep an eye on the big picture, the whole word. It will also encourage you to give crazy solutions a shot. These are the things that will make your design shine.

Keep your hand relaxed. Don't press the pencil too hard against the paper

Applying pressure will not make your drawing better; it'll just make your hand tired and make you want to be done soon. Relax your hand and enjoy the process.

Draw relatively big — but neither too large nor too small

The scale should be large enough to let you work comfortably on details and small enough so that you don't spend hours executing a sketch.

Do not work with outlines

Restricting yourself to outlines does not allow you to see how light or heavy your shapes really are. Fill your letters, even if roughly.

Do not draw single letters

We design words, not single letters. Focus on the big picture first; move on to the details only once you have found the overall shapes and composition.

Draw fast

Spending less time with each drawing will help you try out more different shapes and solutions, which will lead to a more successful result.

Go from the general to the specific

Don't get lost in details too soon. Work fast and focus first on finding the overall composition and basic shapes of your design. Toward the end of the process, you can work more slowly and concentrate on the details.

Don't get attached to your first drawing. Be disrespectful with it!

Look at your first drawing as the starting point that will change for the better as you move further into the process.

Keep an eye on the whole picture

Always keep in mind all parts of your piece during the sketching process.

Keep an eye on spacing

Don't forget that the space between and around the letters is an important part of your design. Use the white space within and between your letters as a reference point for proportions.

Try different solutions

Don't assume that there's just one way of drawing a certain letter. Try all possible solutions you can come up with and then decide which shape fits your design better.

Decorative elements are part of your design

Flourishes are not add-ons that you can decide on later. Draw them together with your letter shapes. Plan them into the structure of your lettering piece.

Favor radical changes over small modifications

Make radical changes to your design and see how the shapes react. Let yourself be surprised by the process.

Working with Layers

In this section I will explain the process of using layers of tracing paper to improve your drawing and give some advice on how to make decisions and handle mistakes.

Your first sketch is done. Ideally it was a fast process. Now look at your drawing in a critical way. You will notice things you don't like and you will think of features you would like to add. Place a sheet of tracing paper on top of your first sketch and copy the things you like about your previous drawing, while making the changes and adding the details you have decided on.

When you're done, repeat the same process again: look at your sketch, decide what works and what doesn't, add another layer of tracing paper, and continue improving your drawing.

The idea behind this technique is that you carry on the successful solutions to the next step and try out new ones at the same time, without having to start over or ruin your previous drawing. You can be disrespectful with your sketches, because you have nothing to lose!

On the following pages you will find some of the layers of my process of designing the lettering for the cover of this book, including notes and tips.

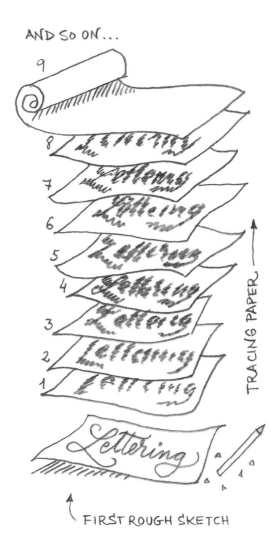

AND SO ON...

TRACING PAPER

FIRST ROUGH SKETCH

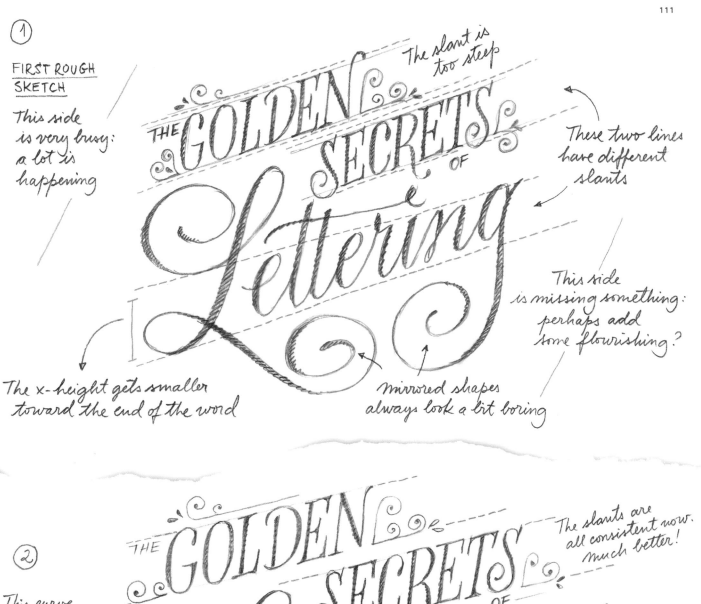

1

<u>FIRST ROUGH</u>
<u>SKETCH</u>

This side
is very busy:
a lot is
happening

The slant is
too steep

These two lines
have different
slants

This side
is missing something:
perhaps add
some flourishing?

The x-height gets smaller
toward the end of the word

mirrored shapes
always look a bit boring

2

This curve
is friends
with those
of the t and g

A new shape
for the L

When two letters
of the same kind are
sitting next to each other,
draw them differently.
It'll look more graceful

The slants are
all consistent now.
much better!

This curl is a nice
counterbalance to the
curl of the L. The composition
is more even now

③

I wonder what the design will look like when executed with a broad nib? VOILÀ!

What about some subtle shadow beneath the letters?

Trying out another decorati element

THE GOLDEN SECRETS of Lettering

The x-height is smaller than before

"Lettering" now looks somewhat stiff and old-fashioned

When trying out broad-nib strokes, make sure to sh the letters eve (moving you pencil back an forth the san distance). This w the contrast wil more consistent

Returning to pointed-nib lettering

UPWARD = THIN STROKE

DOWNWARD = THICK STROKE

④

THE GOLDEN SECRETS of Lettering

If the n has a loop, the g could have one too

N g

Ligature, yeah!

A new e

Trying a roun stroke endi

Capitals are a good place to add fancy flourishes without compromising the legibility of the text. They can be extravagant and oversize

The elliptical shapes in the flourishes should be more consistent

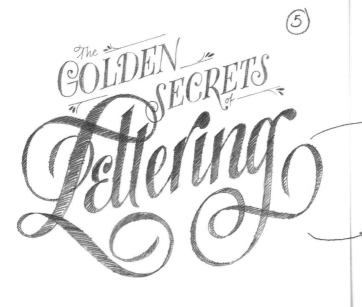

⑤

Explore how
your design reacts
to a radical change

↳ I simplified
some letter shapes
to gain space
for thicker strokes

→ "Lettering"
has become
much bolder

What about combining "golden Secrets"
from here with "Lettering" from there?

⑥

Cool! It creates
some nice contrast
between the
two parts

The letters are
a bit less slanted now

The stroke
thickness should
look the same
throughout.
Compare the strokes
of the i with
those of the n

a new e

The stroke endings are
more pointed now

The Sketching Process at a Glance

Here is an overview of the sketching process of my lettering piece, from the first thumbnail sketches to the refined final drawing.

Of course, the process varies according to each project: some will require more intermediate steps than others. The first thumbnail sketches are rough and quick, while the drawings toward the end of the process are more polished and detailed and take more time to execute.

Layer 6 seems like a good point to move on to digital drawing. Why? Because it looks like I have solved the big problems. Or at least I think I have for the moment.

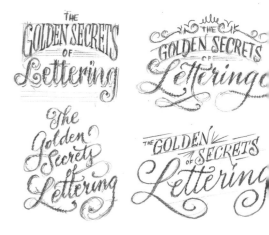

THUMBNAILS

The small two-inch sketches determine the overall composition, possibly define the style of the lettering, and show how the desi sits on the page.

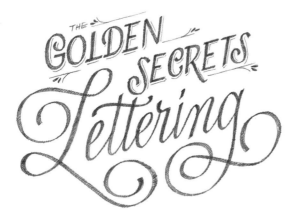

LAYER 3

Experimenting with a different calligraphic principle for the shapes of my letters. Addition of new, more laid-back decorative elements and shadow.

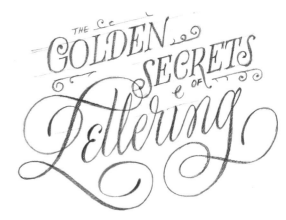

LAYER 4

Returning to pointed-nib lettering. Exploring variations of shape for the *e* and capital *L*.

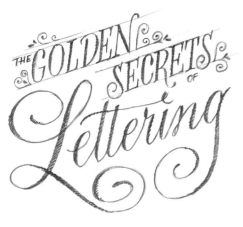

LAYER 1

Reproduce the best thumbnail sketch in a bigger size. Choose a format that will provide enough space to work on details but is not so large that you get lost in them. Letter size normally works well.

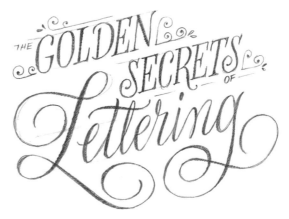

LAYER 2

First layer of tracing paper. Finding consistency in the slant of the baselines and improving the overall balance of the composition. Trying out different solutions for single letters.

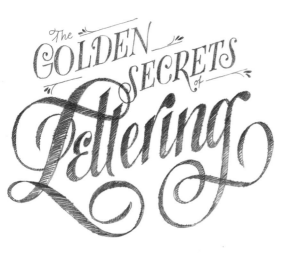

LAYER 5

Another experiment: a radical change in the weight of the word *Lettering*, forcing me to try new, simpler letter shapes.

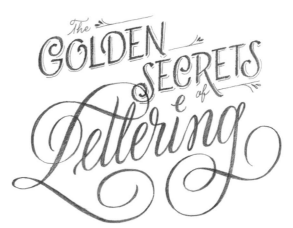

LAYER 6

Combination of broad-nib lettering from layer 3 for *Golden Secrets* and layer 4 for *Lettering*. Most of the problems are solved, so I'm ready to scan the drawing and start working digitally.

Chapter 8

- ▸ The digital drawing
- ▸ Working with extreme points

ANCHOR POINT

HANDLE

- ▸ Digitizing your sketch

8

From

ANALOG

to

DIGITAL

Vectorizing your lettering

The Digital Drawing

The "final" hand-drawn sketch of your lettering becomes the basis of your digital drawing.

Go ahead and scan the sketch. Because I like to keep a high-resolution digital backup of my sketches, I generally scan them at 600 dpi, but 300 dpi is more than enough.

Once you have your sketch as a digital file, prepare your working space by creating a new document in your favorite vector drawing software, based on the same dimensions. Place the lettering file as a background image and create a new layer. This is where you are going to start your digital drawing.

At first, drawing digitally will feel like walking on the moon: everything moves much slower. Why? Simply because the lines and curves are much more accurate now, and it is therefore easier to identify defective shapes.

Although you can still make small decisions and minor changes while digitizing your lettering, the main problems should be solved on paper. If you want to make further overall design changes or add flourishes, you should return to your hand sketch.

When you move on to the digital environment, what you essentially do is to translate your hand drawing into digital vectors. Vectors are paths that are defined by points, whose positions in turn are the result of mathematical equations. It works a bit like drawing by numbers: the shapes are the result of connecting the points.

There are several software programs you can use for this purpose, and you may choose freely among them and use the one you feel most comfortable with. For our purposes, the power of the tool is not in the amount of effects you can achieve with it, but in how useful and intuitive its drawing tools are. All of the super-duper effects can be greatly tempting for someone who is a beginner in the art of lettering, but it's better to stay away from them for now and stick to the software's basic tools.

You need:
✓ A computer with vector drawing software installed
✓ A scanner (or you can take a picture with your smartphone
✓ Copy paper and printer

Cover for Walker Books.
AD: María Soler Canton

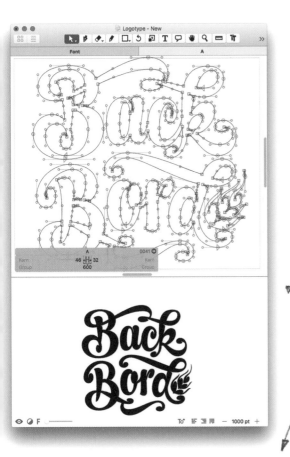

I use the following
software programs:

GLYPHS
Originally a font editor but also a great
tool for drawing letter shapes. Good for
logotype design and black-and-white
lettering

ADOBE ILLUSTRATOR
Vector drawing software that is great
for full-color drawings. A convenient
tool for adding color and texture

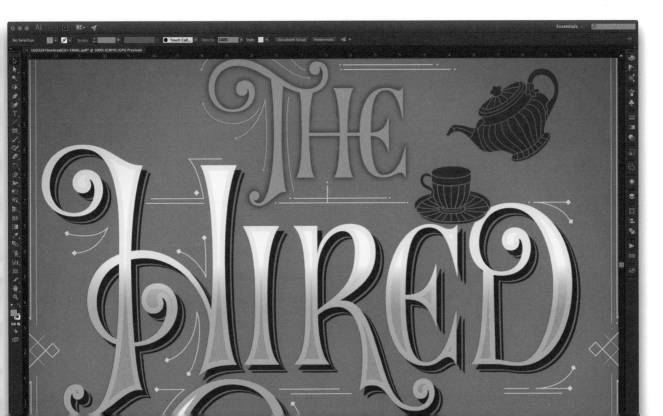

Working with Extreme Points

The key to vectorizing letter shapes is to work with extreme points. The main goal of this method is to reduce a letter's number of vector points (also called *Bézier points* or *anchor points*) to the minimum and thus make the editing process as easy as possible. The formula is quite simple: Fewer points = less work.

The extreme points are found in the horizontal or vertical tangents of our shapes—i.e., at the extreme points in each direction, namely the northern-, southern-, eastern-, and westernmost points.

Of course, most letter shapes are more complex than a circle, and you will need a lot more vector points to describe the form.

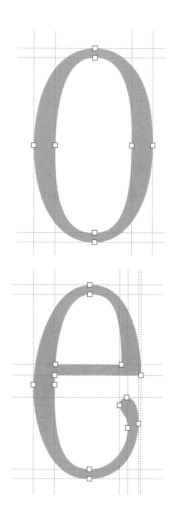

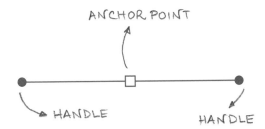

Handles are also called *control points*, because they control the shapes. Altering any of the points or handles will directly impact the form of the adjacent segments.

Vector points are defined by three elements: a central anchor point and two handles, or control points. The section between two anchor points is called a *segment*. There are two different kinds of segments: Straight segments consist only of two anchor points. Curved segments in addition require the two handles, with which you can vary the radii of the curves.

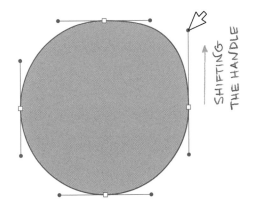

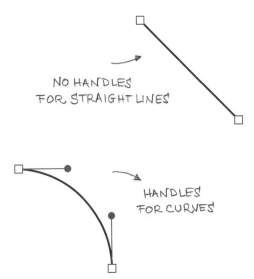

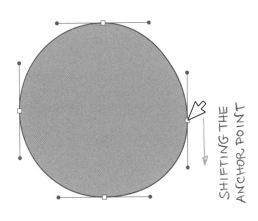

As a general rule, handles should always be placed on the horizontal or vertical axis and not on a diagonal. This will allow you to control the handles more precisely and, most importantly, avoid unnecessary points!

A curve is defined by the position of the anchor points and the length of the handles. The closer together the anchor points are, the tighter the curve. To achieve a smooth curve, the handles should ideally share the job, i.e., have a similar length. In addition, one handle should not go beyond the position of the other.

no

Yes!

no
(the handle
is too long)

Because
the anchor
point is
too low

Yes!
(evenly
balanced
handles)

Hold the shift key when editing your handles. This will keep them on the horizontal or vertical axis (in most software programs)

no

Yes!

no
(One handle goes
beyond the position
of the other)

the latter does happen, the anchor point is probably at the wrong position. For although handles play a major role in defining curves, the position of the points is even more important. Our job (and challenge) is to find the right balance between all of these elements.

Although the process seems to be a complex science at first glance, you will quickly understand its logic through practice, and vectors will soon become your best friends.

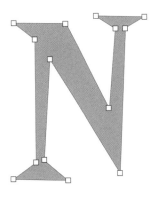

ANCHOR POINTS
CLOSE TOGETHER
=
TIGHTER CURVE

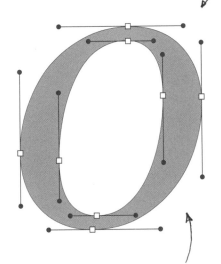

ANCHOR POINTS
FARTHER APART
=
SOFTER CURVE

Refrain from clicking the "Auto Trace" button! This will only turn your sketch into millions of points that you will not be able to edit in years.

USING THE AUTO-TRACE
FUNCTION

USING EXTREME
POINTS

No, way too many
anchor points

Yes!

Digitizing your sketch

As we work on our digital drawing, we continuously improve and refine the shapes of our hand sketch. We pursue "the perfect curve" by placing and improving the positioning of anchor points and handles. It is artisanal work in the digital environment.

Start by locating the extreme points in your sketch and place your anchor points. Remember that the fewer points your drawing has, the easier it will be to work with.

Keep your sketch in the background and place the anchor points on a new layer. Just as you did with your hand drawing, work with layers in your digital drawing too, always creating a copy of the current layer when you continue on to a next step. This allows you to measure your improvements and compare solutions. By saving your previous steps, you'll be able to easily recover shapes that you liked better.

When digitizing your sketch, make sure to keep each individual stroke separate. You'll find out why this is important on the next spread.

This symbol represents the tool used for shifting anchor points and editing the handles

DEN SECRETS of
e
ttering

This symbol represents
the tool used for adding
anchor points

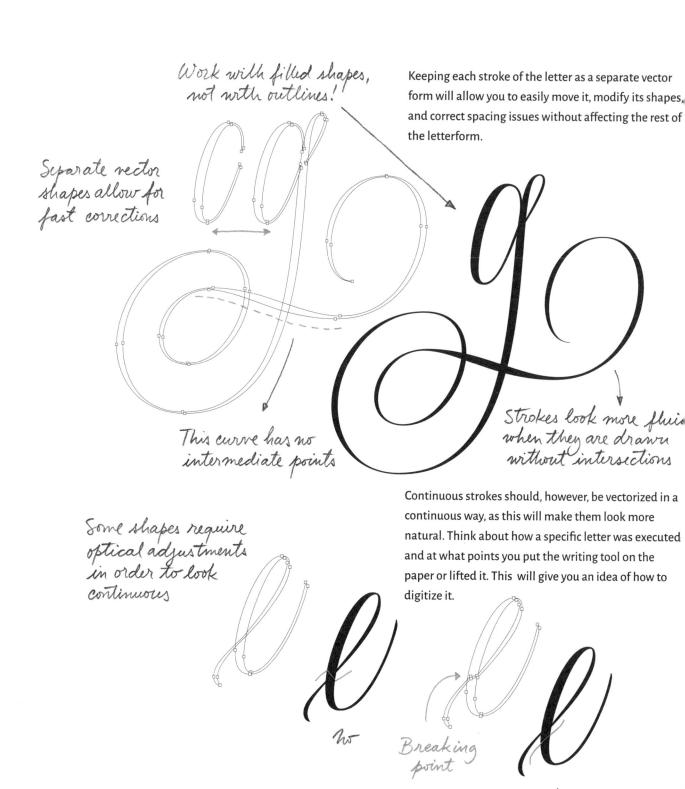

Work with filled shapes,
not with outlines!!

Keeping each stroke of the letter as a separate vector form will allow you to easily move it, modify its shapes, and correct spacing issues without affecting the rest of the letterform.

Separate vector
shapes allow for
fast corrections

This curve has no
intermediate points

Strokes look more fluid
when they are drawn
without intersections

Continuous strokes should, however, be vectorized in a continuous way, as this will make them look more natural. Think about how a specific letter was executed and at what points you put the writing tool on the paper or lifted it. This will give you an idea of how to digitize it.

Some shapes require
optical adjustments
in order to look
continuous

no

Breaking
point

Yes!

etters that are connected with each other, as for
xample in script lettering, should be kept separate in
our vector drawing. This will help you achieve cleaner
hapes and fewer anchor points. It will also be easier to
orrect letterspacing.

Separate letter shapes allow for faster corrections of letter spacing

SEPARATE FORMS:
SEVENTY-NINE POINTS

CONNECTED FORMS:
ONE HUNDRED POINTS
(more points always
means more work!)

The processes may vary according to each project: some
will require more intermediate steps than others. Be
sure to print out your design from time to time. Once
the printout is on your desk, you can look at it, take note
of mistakes, try different solutions on paper, and write
down your ideas for further steps. This is your waybill
for the next move: executing those corrections.

Merged intersections result in four additional points

Chapter 9

▶ *Coloring*

Different atmospheres

▶ *Adding texture*

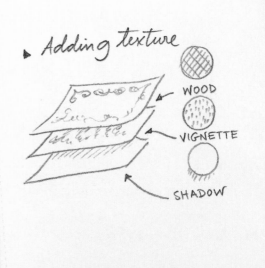

WOOD

VIGNETTE

SHADOW

9

The Finishing Touch

Adding color and texture

Coloring

Digital drawing tools help us create sharp and polished letter shapes, as vector points and handles give us very precise control over the forms of each stroke. However, this technique also influences the appearance of the resulting drawing and can lead to a "digital" look. Adding color and texture helps remove the digital aspect and adds back some tactile feel to your lettering.

Keep in mind, though, that applying trickery and effects may both disguise poorly executed lettering and distract from beautifully executed letter shapes. It is easy to succumb to the temptation of using such effects in abundance, but our primary focus must be on perfecting the letterforms. Therefore, it is important not to move on too quickly to the finalization phase.

Once again we will work with layers to add texture, shadows, decorative elements, and color. Using layers will enable you to try out different effects and easily return to previous solutions. While working on finalizing your piece, make sure never to forget the stars of your work: it is the letter shapes that need to shine!

Cover for
Net magazine
AD: Rebecca Shaw

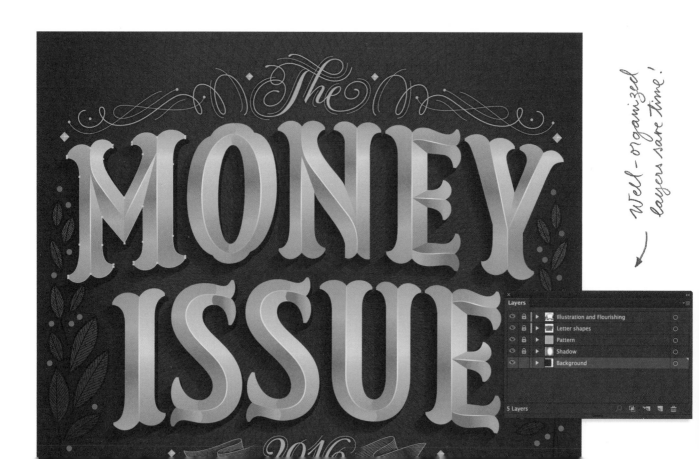

Choosing a color scheme for your drawing is not about simply mixing colors that you like or that go well with each other. The color of a piece should accentuate and accompany the message you want to communicate or the atmosphere you want to create with it. Color selection also depends on the amount of contrast your design requires, what elements you want to highlight, and what parts should stay in the background.

Color is a huge field, and it is an essential part of the creative work of every designer and artist. There are many good books on color theory out there, and I will not even try to pretend to come close to them here. Instead, I will talk about general aspects of color and mention some sources of inspiration that you can use to find color palettes for your lettering.

The first step, however, is to clearly define what you want your piece to convey or what atmosphere you would like it to have. This will narrow down your search for inspiration.

I recommend you start by choosing a palette of two or three colors. Although this may seem limited, you will see that it allows multiple possibilities when applied in your piece.

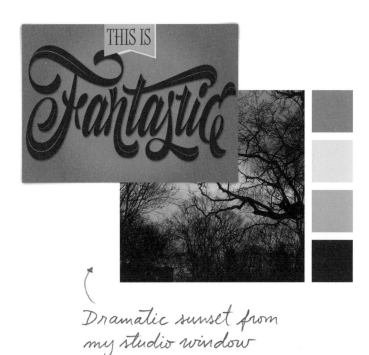

Dramatic sunset from my studio window

Warm fall afternoon

The effect of the chosen color scheme will depend on the way it is applied. You will arrive at different results, depending on which color you use for which element. The selected color will also determine the amount of contrast—and whether your piece will vibrate or look smooth.

The color scheme on this spread is based on the two colors used for my handwriting throughout the book

Explore different possibilities for applying your color scheme. Search for the best solution

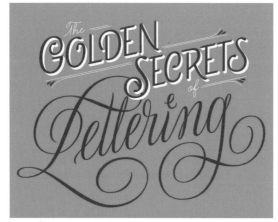

↘ Lack of contrast

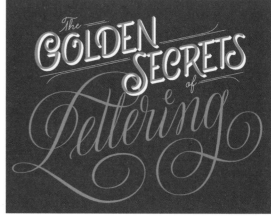

↘ Vibrates!

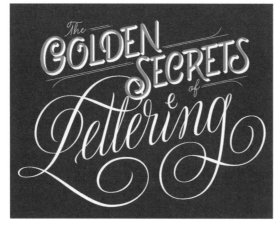

↘ The background "devours" the letters

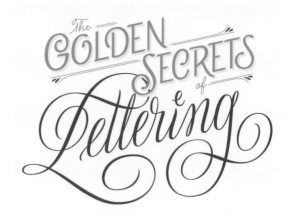

↘ Looks good!

A very light gray shadow added behind the letters gives them dimension

Because the red color appears lighter than the blue, this text remains in the background

The GOLDEN SECRETS of Lettering

But I do add a bit of blue in the decorative elements

The word *Lettering* looks darker and stands out from afar

In the black-and-white version, "Lettering" is even more emphasized

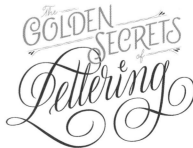

Adding Texture

Every object in the real world has a certain texture, which is part of what allows us to differentiate one thing from another. Working with lettering in the digital environment allows us to achieve precise and well-shaped letterforms. But as I mentioned, it has a downside: the result can look very flat and "digital."

To counteract this cold, homogenous look we add texture, which is basically anything that helps add noise and naturally-looking irregularities to your design. It will make your piece look tactile, volumetric, or dimensional, depending on the effect you want to achieve. With texture, your design will not look so digital anymore and will start to belong to the real world.

WITHOUT TEXTURE WITH TEXTURE

Digital film grain applied only to the background and shadow

WITHOUT TEXTURE WITH TEXTURE

Subtle photocopy texture applied to the background and paint splatters on the letters

You can create texture from almost anything that surrounds you. As the lettering's creator, it is up to you to decide how much texture is necessary and what kind of texture is suitable for your design.

A small library of various textures is very handy and easy to create. Scan surfaces with different characteristics, such as fabric, paper, or plastic, for subtle texture effects. Or take pictures of surfaces (with reflected light effects, if possible) and adjust their contrast using a picture-editing software.

I save most of the textures for my library in black-and-white, so I can choose color later on. Some are based on photos of old pieces of paper and other materials or surfaces. Others are scans

I digitally manipulate most of the textures (by increasing contrast, changing color, etc.)

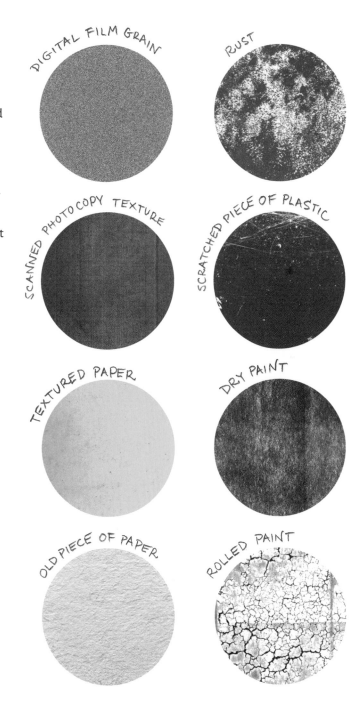

DIGITAL FILM GRAIN

RUST

SCANNED PHOTOCOPY TEXTURE

SCRATCHED PIECE OF PLASTIC

TEXTURED PAPER

DRY PAINT

OLD PIECE OF PAPER

ROLLED PAINT

Working with layers, you can apply different textures to different parts of your lettering. You can, for instance, use a wood texture for the background, a photocopy texture for your letterforms, and an old paper texture on top of everything.

Since layers of texture will increase the density of the overall design and make it darker, you'll need to adjust its color, saturation, opacity, and transparency. Trial and error is the best way to find out what settings work best for your piece.

Drop shadows and gradients can help give your design additional texture. However, it is a fine line between a drop shadow that improves the design and one that ruins it. A rule of thumb here is: the less you notice a shadow, the better!

Bear in mind that not all lettering requires the same amount of texture. Some designs may even look better without! Think of texture as just one of the tools in your toolbox that you may wish to use (or not).

WITH TEXTURE

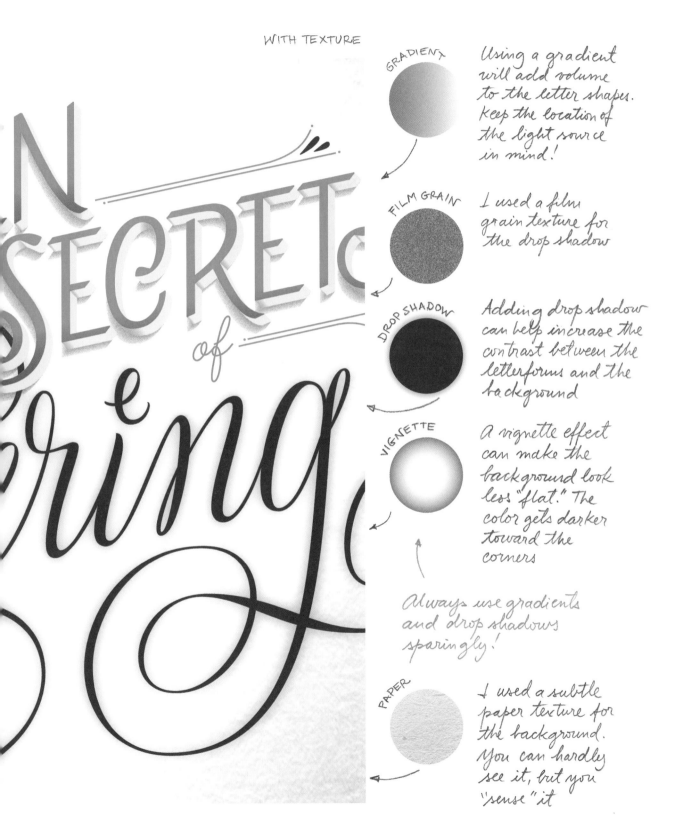

GRADIENT

Using a gradient will add volume to the letter shapes. Keep the location of the light source in mind!

FILM GRAIN

I used a film grain texture for the drop shadow

DROP SHADOW

Adding drop shadow can help increase the contrast between the letterforms and the background

VIGNETTE

A vignette effect can make the background look less "flat." The color gets darker toward the corners

Always use gradients and drop shadows sparingly!

PAPER

I used a subtle paper texture for the background. You can hardly see it, but you "sense" it

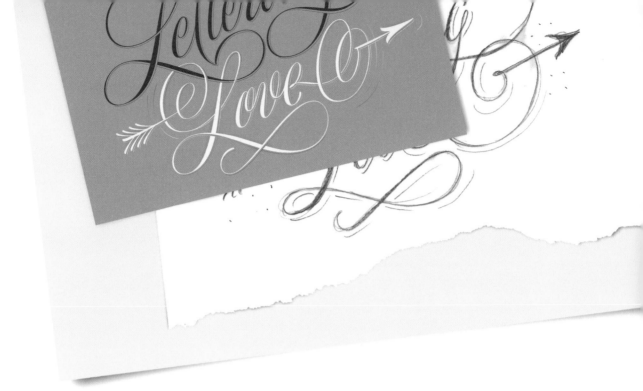

Chapter 10

- The work of a lettering designer
- Being your own client
- Showcasing your work

Do you need an agent?

Your own website

Pricing your work

- Tips for a productive workflow

* The creative brief
* The roughs
* Feedback

* Digital drawing
* Timing

* Delivering finals
* Getting better

- Checklist for good lettering design

10

WORK IN PROGRESS

Becoming a professional lettering designer

The Work of a Lettering Designer

The work of a lettering designer is positioned between the fields of design and art: it requires the systematic approach of a designer and the keen eye for forms of a visual artist.

Which side it stands on often depends on the job—on whether it is a personal project or a commercial commission, and on whether the client asks you to show your voice in the piece or wants you to communicate a precise message.

The work of a lettering designer is often comparable to that of an illustrator. The task of both is to interpret content and transform it into an image.

As a letterer you have several income options. You can work for clients or agencies; you can sell your lettering in a shop or in art galleries; or you can license your artwork for products. You can specialize in one of these or do a bit of each.

I love doing commercial work. One reason is that it often involves interacting with an art director or editor who will help make my piece better. I also find it fascinating to see my work in the real world: on the cover of a magazine in a newsstand or a book in my favorite bookstore.

Lettering projects vary in scope but they tend to have tight deadlines. Their intended purposes (and thus the best ways to approach them) can also be widely different, depending on the type of commission. Each comes with its own challenges.

On the following page you will find some of the most common commissions for lettering designers and some notes on what each involves.

magazines and newspapers

COVERS

Job: Designing lettering for a header or to accompany an illustration. Creating a complete lettering cover, if you're lucky.

Challenge: Having to work around pre-designed elements, such as the masthead or barcodes.

ARTICLE ILLUSTRATIONS

Job: Designing illustrations for an article.

Challenge: Dealing with various kinds of formatting within the text. Choosing the right kind of atmosphere to fit the content.

PAGE OPENERS

Job: Your lettering introduces the story of an article.

Challenge: There will be few restrictions; your lettering is the star of the piece and should shine!

HEADLINES

Job: Designing a headline that illustrates the text.

Challenge: A part of the page will be reserved for the headline. Your lettering should reference the content of the text in some way.

Logotypes

Job: Creating a typographic identity that works equally well for a range of applications. You'll probably need to create black-and-white and color versions that can be used in various sizes.

Challenge: Optically adjusting the lettering for use at large and small sizes.

Book covers

Job: Expressing the content of the book in your lettering, sometimes in combination with an image.

Challenge: Working with given images. How well the book sells will partly depend on your cover design.

Posters or billboards

Job: Creating an interesting piece of lettering that catches the eyes of passersby.

Challenge: The poster will include various levels of information, which may require combining your lettering with suitable type.

Packaging

Job: Designing a distinctive piece of lettering that expresses one or more characteristics of a product. You'll probably collaborate with a packaging designer.

Challenge: Making the product stand out from other products on the shelf.

Ephemera

Job: Designing lettering for invitations or notecards.

Challenge: The atmosphere of the design has to match the occasion.

Apparel

Job: Creating an attractive lettering design that people will want to wear on their clothes. You'll usually have lots of freedom for your design.

Challenge: Production techniques may limit the number of colors and effects you can use.

Tattoos

Job: Your lettering will be inked into someone's skin and remain there forever. Are you sure you want to take on this job?

Challenge: The reproduction technique limits the number of colors and effects you can use.

and lots more …

Being Your Own Client

Finding occasions to produce lettering work can be difficult, especially when you don't have clients (yet).

My advice is: set your own tasks. Create a poster, design a postcard, make a greeting card for a friend, or write a shopping list—draw letters as much as you can! Stop waiting for a dream project to come your way; start it yourself! You just need to invest your work and time (and perhaps a bit of money) in order to become your own client.

If you have no art director or client to evaluate your work, find your own audience. Start a blog, put up a portfolio site, use social networks, or attend design meetups. Getting your work out there will give you the opportunity to show what you do and prove your interest in the topic. It will put you in touch with

Lettering vs. Calligraphy was my first side project, a collaboration with Italian calligrapher Giuseppe Salerno. Using an online platform, we would choose a letter. Giuseppe then used calligraphy to execute it, while I drew the letter shapes. This project brought a lot of attention to my work and also improved it, because it "forced" me to design lots of different kinds of letterforms in a short period of time.

letteringvscalligraphy.com

ike-minded people who can act as a critical eye for you.
ust the mere fact of knowing that someone will be
ooking at your work will push you to create better
pieces and to top yourself.

Displaying your lettering will also help you keep a
record of your work. You'll be able to see your progress
as you create more and more pieces.

It is very likely that what you show your audience today
will not seem so wonderful to you tomorrow, but this is
normal and simply proof that your typographic eye is
becoming more discerning every day!

Letter Collections is my most
recent side project. It involves
designing postcards and
sending them to friends, col-
leagues, and complete strangers.
For this project I draw words
or sentences rather than single
letters. My goal is to design
one hundred postcards. I send
them as physical objects but
also make them available
online so that other people
can use them. In this project
I experiment with lots of
different lettering styles and
hone my management skills,
as I work on the postcards in
between commercial commissions.

lettercollections.com

Showcasing Your Work

In order to start a career as a lettering designer you should be able to show potential clients a selection of good lettering pieces. But how do you build up your body of work if you do not yet have commercial clients? As discussed before, you can become your own client and set your own tasks, in order to expand your portfolio and improve your work.

However, having commercial clients is important, not only for your wallet but also because it will affect your future work. The pieces that you will show as part of your portfolio will arouse the interest of potential new clients and will thus directly influence the kinds of commissions you will get in future.

There are several ways of showcasing your work, and I dedicate a large amount of time to thinking of ways of reaching new audiences. I particularly enjoy designing greeting cards with holiday wishes at the end of the year and try to come up with novel ways of designing the cards each year. I also frequently print postcards or posters that I can give away to people at conferences, workshops, and other events.

Every little piece of lettering that I put out there helps point people to my work and draws them to my website. Every time I participate in a social network and every time I give away a postcard or business card, I'm hoping to encourage people to visit my online portfolio and discover the rest of my work.

A portfolio that is current and up to date does not only display your work to potential clients. It also gives you an overview of your past projects and will spark ideas about what kind of work you want to do next. Before starting a new commission, I often go to my website and look through my portfolio of projects. This way I can reflect on what I have done and determine which other directions I would like to explore.

Some clients will want you to replicate the style of a project that you did in the past. This is good in a way, because by perfecting a certain style or technique, you can take it to the next level. On the other hand, replicating work can become boring for you and quickly turn you into a one-trick pony. My advice is: try to convince the client that you are proficient in other styles as well.

A careful selection and presentation of your lettering pieces can help you keep your work moving in new directions. When putting your portfolio together, there are several things you should bear in mind:

Present your work as projects

You will want to introduce yourself as more than just a "pretty-picture maker." You are also a conceptual thinker and creative individual. Your portfolio should reflect that by briefly sharing some insights on each project, including aspects about the briefing and your inspirations. Do not forget to mention your collaborators (e.g., the art director or editor) and the client.

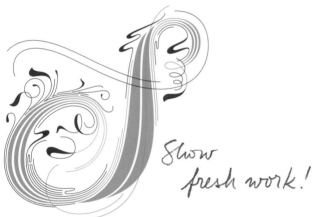

Show fresh work!

You should always keep your online portfolio up to date, so make sure your website is easy to update. Avoid complex intro animations and multiple languages. Your site should be easy to navigate for your potential clients, and it should showcase your latest and best work (see also "Edit your work," p. 146). Although you might currently have plenty of commissions, keeping your website current with fresh work will help ensure you new commissions in the months or years to come.

Edit your work

Your portfolio should reflect the kind of work you want to do in future. You don't want to do any more calligraphed wedding invites? Then certainly do not post the last set of invitations you did for your cousin's wedding! If you accepted a job just to pay the bills, or a commission led to something that you are not proud of, don't include it on your website! Do not show pieces that you don't like; show the projects you want to do more of.

measure your efforts

Once you have a smart-looking site, ideally you simply need to point potential clients to it. But how do you know whether people are visiting your site and checking out your fresh work? How do you know whether certain promotional actions you took helped bring traffic to your website?

Luckily, there are tools to measure this kind of data. Adding a simple Google Analytics code for your site will tell you which of your projects are the most visited in your portfolio, where the traffic is coming from, and what kind of audience is interested in your work.

Know your clients

It is important to set yourself a horizon and define whom you would like to work for. If you aim to work internationally, start, for instance, by making your website domain name end with ".com." If your potential clients speak English, do not waste your time translating your website into different languages.

Social networks — yes or no?

Letter design can be quite a lonely job. You often collaborate with clients and art directors, but at the end of the day, it is you on your own shifting those anchor points in your vector drawing.

Participating in social networks has balanced this out for me. It has opened up a daily dialogue and put me in contact with many people who are interested in what I do. They encourage me to do more of it and do it better, thus becoming a key force in improving my work. It is true that participating in social networks can be time-consuming and distracting, but hey, we are spending much of our time there already anyway, so we might as well use them professionally.

One downside of social networks is that the content is community driven: under the hashtag #lettering on Instagram, you will find numerous images, some of which are not in fact lettering and many whose quality is questionable. To an inexpert eye, your work may look at the same level as all the others. Nevertheless, many editors and art directors (who do have an educated eye) perform talent scouting using social networks, so it might be a chance for you to get your next commission.

Put yourself out there

Don't hide away in your studio; take part in the creative community. Art directors, designers, or shop owners will more likely reach you through a side channel than directly through your website. People work with people they like, whether they like you on Instagram, follow your blog, or meet you at CreativeMornings. Find your favorite way to be present: go to conferences or design meetings, have an active Instagram account, or post on Twitter. Or better yet, try them all. This may sound like a lot of work—and it is—but it is worth it and you might have a lot of fun in the process.

Do You Need an Agent?

Working with a representative is one option for a lettering artist who wants to do commercial work. Because the work of a lettering designer is often comparable to that of an illustrator, illustrators' agencies have started including lettering designers in their portfolios of artists. There are a number of reasons why you may choose to join an agency.

Working with an agent can help you reach clients whom you would otherwise not get to, simply because certain types of clients speak directly with agencies rather than doing a Google search for a "lettering designer" and calling you on the phone.

Big clients often prefer working with agencies because the latter are familiar with contracts, licensing terms, and disclosure agreements, which freelancers often are not. This is also a good reason for a lettering designer to search for a representative: an agency will make sure your work is protected.

Moreover, having an agent will help you dedicate your time to doing what you do best: create artwork. If you don't have an agent, you may at times find yourself discussing your fee with the same person who will lead the creative process, which can be slightly uncomfortable for both parties. If an agent discusses those terms for you, this can also enhance the perception of you as an artist, since in the eyes of your potential client you are too busy creating awesome things to have time to speak about such mundane matters as money.

Cover illustration for New Statesman magazine. AD: Anja Wohlstrom

This is my first commission, which I received exactly three hours after signing with my agent. Luckily, it was followed by lots of other commissions for magazine covers

Beyond dealing with money and protecting your rights, an agent will help you promote your work and improve it, at times giving you feedback about which pieces are successful and loved by clients. Since the agent is your representative, you will want her or him to deal with issues and clients in a professional way, adhering to manners and values that you relate to.

Agents charge a percentage of the total fee of a commission. This percentage and the terms of collaboration vary from agent to agent. Some allow you to have your own clients on the side without the agency's involvement. Others ask for exclusivity, which means that all commissions you get as a professional lettering designer have to be managed and negotiated by them.

Some agents leave the artist the full rights to the work, while others bind the work to the agency. The latter means that you will be able to show the projects you got through the agency as part of your portfolio as long as you are under contract with the agency. However, once you decide to go on your own or sign with another agent, you will have to get the agency's permission to display your own drawings.

Research a few agencies that seem to fit your work and

negotiate the terms of your collaboration and read the contract thoroughly before signing it!

put your efforts into getting their attention rather than sending promotional material to lots of agencies at random. Successful agencies receive applications by artists all the time, so try and find a novel way of approaching them. Trade fairs, art shows, and other events present an opportunity for meeting agents face to face.

"3 for 13" stands for "three wishes for 2013"

I signed with my agency in 2013. I sent a new Year's greeting card with my three wishes for the upcoming year. The agency called me a few days later, and we have been working together ever since

Pricing Your Work

The fee you charge for your work depends on a combination of several factors:

 Timing

What are the deadlines? How fast do you have to complete the piece? Do you need to push back or reject other commissions to get this one done?

 Complexity of the job

How many revisions does the client require, how complex should the lettering be, and how many steps will it take to draw it?

 Terms of usage

How long will the lettering be used by the client (a year, five years, unlimited time), in which media (TV, billboards, magazines), and in which territories (USA, English-speaking countries, or worldwide)?

TIP:
I strongly recommend the Graphic Artist's Guild Handbook of Pricing and Ethical Guidelines, a comprehensive reference book with information on pricing your artwork and other contract terms, including sample contracts

 Exclusivity

Is the artwork exclusive for that particular client? If so, this means that although you as an artist still own the copyright on the artwork, the client is the only one allowed to exploit it commercially. If it is not exclusive, you can make additional profit from it; for instance, by selling prints of that artwork online or by licensing it for use on products.

 ## application

How will your work be used? Is it a logo, an illustration for a T-shirt, or an advertising campaign? What is the size of the print or production run? Knowing exactly how your piece will be used will give you an idea of how much money will be invested in the entire project, which in turn will help you calculate the price of your work. Charging $500 for an artwork that will be used in an advertising campaign that invests $120,000 in renting billboards alone would be disproportionate, for example.

 ## Client size

How economically powerful is the company you will be working for? This is directly related to the size of the production run and distribution of your piece, and how much profit the company will make from it.

To build a sustainable career as a lettering designer, your fees should be realistic for both yourself and your client. While you do want to get the job, you also want to make a living from your work. Accepting a commission that is underpaid today might mean a chain of clients who expect the same low fees in the future. On top of that, this underpaid job will prevent you from investing time in other, better-paid projects or in acquiring new ones.

However, in some cases it might make sense to be flexible about your fee, for example for a job that you really want to do and that will lead to a great piece in your portfolio. If you are interested in a commission that does not pay as well as you would like, think outside the box to find other forms of compensation. Perhaps there is an opportunity for a trade-off, or you can make the deadlines a bit more flexible, reduce the number of revisions required, or limit the usage of the artwork to a certain time frame. Bear in mind that money is not the only figure you can negotiate.

Make sure to establish a professional contracting system. This will protect your work as well as set clear conditions under which the job is done. The contract should state all the terms you negotiated with the client. Make sure to also define the conditions of payment in case the work is canceled or the client is not happy with the final result. And most importantly, include a statement specifying that the copyright of the work remains with you. This will give you the right to show your piece as part of your portfolio to other potential clients.

Tips for a Productive Workflow

Drawing letters is an incredibly slow-moving job. This is one of the first things I realized when I started working on lettering full time. Since I ran a one-woman studio and wanted to make a living from it, I had to improve my workflow to be able to do multiple projects at the same time and respond to the working rhythm of agencies and publishing houses (where projects are due yesterday).

Developing a good sketching technique is enormously helpful for this process. Sketching helps me quickly visualize an idea, discuss it with the client, and have enough time for the digital execution afterward.

Working with quick sketches is convenient for both the lettering designer and the client, as it allows you to deliver a concept in a short time and confirm if you are both on the same page regarding the direction of the project. If not, it is easy to sketch some new ideas and discuss them with the client.

I once received a commission with a really fast turnaround. Although the deadline was extremely tight, I was interested in the job and decided to take on the commission. Once I got the briefing and cleared up some doubts with the art director, I started sketching right away. A few hours later, I sent a first colored sketch to the client. The art director got back to me right away: he loved the direction. However, there was a little problem: I had used the wrong text for the lettering. I had made a huge mistake!

After taking a deep breath, I wrote back apologizing and two hours later I was able to deliver a new sketch using the right text. I got positive feedback and could move on to the digital drawing and finalize the work as quickly as possible. Almost no time was lost considering that, ahem, I had started the project with the completely wrong text! Bottom line: sketching saved that commission, the relationship with the client, and all the future potential commissions that may arise from it.

The commission I almost botched up

*Opener for
5280 magazine.
AD: Dana Pritts & Dave
McKenna*

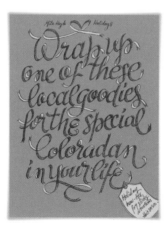

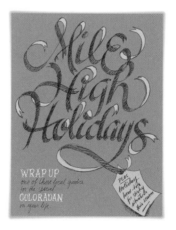

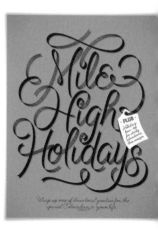

*The benefits
of sketching*

Working with sketches has two more benefits. Although you are establishing a lot of essential elements in your first sketch, many of the details will follow later in the process, which keeps the work interesting for you and thrilling for the client. Another benefit is that sketches enable the client to experience the working process; she or he can see the individual steps and influence them.

Additionally, in the digital era a working process that involves hand-drawn sketches is well appreciated and adds value to your work. Clients will perceive your work as a craft and not only as a job.

As you learned earlier in this book, creating the digital drawing is much more time-consuming than the hand-drawn sketch. Make sure to schedule enough time for digitizing your lettering. Also set aside time in your schedule for presenting your work and getting feedback. This involves emails or phone calls with your client, as well as preparing your files for electronic transfer.

In the following pages I will explain the process of a lettering commission step by step, from receiving the briefing and delivering the first sketches to getting feedback and preparing the digital drawing.

Saves time for you and the client

Allows for quick changes and corrections of mistakes

The client is an active part of the process

Enables you to take on commissions with a fast turnaround

Leaves room for dealing with details later on

In the digital era, handwork is a plus

People will hire you not only because they love your work, but also because you are great to work with, because you come up with creative solutions, or you are skilled at time management. While it is important that you deliver good results, the client will appreciate them even more if the collaboration and workflow were smooth and pleasant in addition.

The Creative Brief

A commission usually starts with a phone call or an email from the client, inquiring whether you are interested in a particular project. You will get a description of the job, including information on deadlines, format, color scheme, usage terms, file format, and, possibly, budget.

There are a few things that you should consider before taking a job:

- Schedule: Can I meet the deadlines for rough sketches and final artwork?
- Budget: If one is given up front, does it fit my expectations? (See "Pricing Your Work," page 150.)
- Artistic demand: Am I the right fit for this commission?
- And most importantly: Do I want to do the job?

In most cases you will be contacted by an art director or an editor. This is also the person who will give you the creative brief and provide feedback on your work.

A good art director is an essential part of interpreting the brief correctly, because she or he has a lot of

Title: *The Crazy Girl*, by Lauren Laura Lou
Genre: general fiction, classic, historical
Target: girls, 12+
Jacket format: 284 mm width (129 back + 26 spine + 129 cover) x 198 mm height.
Schedule: one initial sketch on November 4. Final artwork by the start of December.
Deliverables: vector drawing as a PDF file. Please add 5 mm bleed on all sides.
Jacket design: As the story takes place in the Victorian era, we would like the letter shapes to be inspired by that time. But it needs to look contemporary and fresh rather than old and vintage. We would like to use two to three colors on the cover.
Back cover: We need space for the back cover copy and the barcode.
Spine: Should feature the title, author's name, and our logo. Please feel free to add decorative elements that link the spine to the cover.

Format: Work with the right dimensions from the beginning

Deadlines!

If not listed, ask!

Keywords for the first sketches

Colors

Copy and other predesigned elements

experience in the sort of work the company is commissioning you for. Make sure to get along with this person, because that is key to achieving a smooth, efficient process and delivering a successful final piece.

After receiving the creative brief, think of all the topics that it does not cover and don't be shy to ask questions. Art directors and editors are commonly working on many projects simultaneously, and they will appreciate your asking about things that they might have overlooked. Ideally, answer the client's first email within twenty-four hours. Agencies and publishing houses move fast, and they will not wait around for you. It would be a pity if a job went to someone else just because you did not send your answer fast enough.

In your first email, show your interest in the job and clearly state any questions you may have. Be to the point and make yourself available by phone as well as by email, because some art directors and editors may not have the time to write long answers.

One of the things you should find out is whether the client has already formed an idea of the style the piece should have or if there is a particular project in your portfolio that resonates with her or him.

If you already have some ideas in your head after reading the brief, you could suggest a certain approach. However, do not get into details yet. The first rough sketches should be the place for you to show your ideas.

Finally, you should tell the art director what to expect from you. I normally explain my working process, letting her or him know that I will send a rough sketch along with a color scheme first, and if the direction, style, composition, and color scheme are approved, I will move on to the digital drawing. I explain that my process includes two rounds of sketches and two rounds of amends during the project. If the client approves the terms of your working process, tell him or her you would be happy to take on the job.

If you cannot take on the commission, send a friendly reply, thanking the sender for his or her interest in your work and briefly stating the reasons why you're not able to do the job

✓ Be polite
✓ Clear any doubts you have
✓ Check for typos

The Roughs

Showing your entire exploration and process would be confusing for the client. Therefore, you should present only the best of your initial sketches as your first draft. Art directors and editors are often rushed, and they will appreciate if you make the process economical for them. So unless they request otherwise, show only one or two options as solutions for the brief, implying that you have already filtered through the many options you have explored and are showing only the winners.

Rough sketches do not need to be beautiful or refined. They do need to show the following aspects of your piece:

- its structure
- the stylistic direction of the letter shapes
- the decorative elements
- the color scheme.

The rough sketch may be scanned and digitally colored or submitted in black-and-white along with a suggested color palette. Include a brief description of your inspirations and describe features that your rough sketch does not include, such as shadows, textures, and other elements that will be added later on. However, you don't want to overexplain what the client is already seeing. A good sketch should be able to speak for itself.

Book jacket for Walker Books. AD: María Soler Canton

The client asked for more contrast between the background and the letter shapes

The rough sketch is the basis for discussing the direction of the project with the client. You will get feedback on whether your ideas work for the commission or whether you need to modify them. Discussing this in the rough sketch phase of the project will end up saving you time for the digital execution.

I often share my work in progress with the client through a password-protected web page, where I upload the rough sketches and later on the digital drawing, as well as my written notes on the project, including deadlines, the names of those involved, and one or two paragraphs describing the main points of the briefing. This way the client has a full overview of the job from start to finish, including the round of sketches and final artwork. The link and password can easily be shared by the art director or editor in house without having to deal with large PDF attachments.

*Headline for
Der Spiegel.
AD: Jens Kuppi*

✓ Send only one or two rough sketches

✓ Don't overexplain; let the drawing speak for itself

✓ Be open to suggestions and amendments

The client asked for a more contemporary color scheme

Feedback

Feedback is a vital part of your process. Your chances of delivering a successful final artwork depends to a great degree on your ability to interpret and incorporate the client's feedback into the next iterations.

Feedback can often be overwhelming and discouraging. Don't take criticism personally, and be professional in solving any issues. You will learn with experience that a client's comments serve to improve your work. The design process is never a straight line, and your client's feedback is just one step in the set of iterations that will lead to an outstanding result.

If you think that one of the suggested modifications will not be good for the piece, politely suggest another solution. Remember that you were hired for the job because the company likes your work and trusts your expertise, so rely on your knowledge and experience as well.

In the best-case scenario you will receive an organized list of tweaks and changes the client wants you to make to your sketch. Oftentimes you'll receive feedback in a much less clear way, either in writing or by phone, including a mix of impressions and problems. If this is the case, you should take these notes and organize them as a list of amendments to make and suggest possible solutions to the problems that were pointed out. Send this list to the art director to make sure that this reflects the changes the client wants you to perform. Rather than being annoyed, she or he will surely appreciate your help in organizing the workflow, and

you will save yourself a lot of time by making sure up front that you are heading in the right direction with your work.

If there are numerous changes that mean a radical shift from your original rough sketch, or if the client wants you to come up with a new concept, the fastest method is to present a new sketch outlining the new direction and then have a second round of feedback with the art director or editor to make sure that you are ready to start with the digital drawing.

If there are only a few changes that don't affect the structure of the piece, you can agree with the art

Opener for Vanity Fair
Spain.
AD: María San Juan

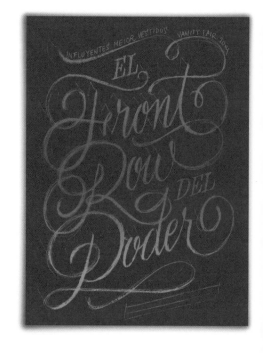

The client wanted sharper strokes

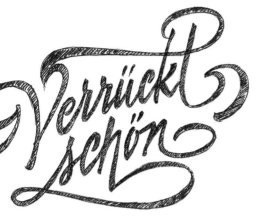

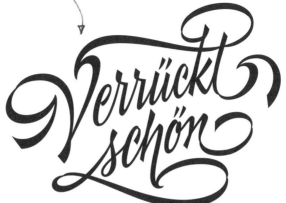

Headline for Glamour Germany. AD: Katja Klinger

director or editor that you will incorporate them directly in the digital drawing.

Before moving on to digitizing your lettering, you want to make sure that the art director or editor approves your concept. Ideally you will want to have this

approval in writing. It is okay to politely ask if the sketch is approved and to state clearly that you will start working on the final artwork based on the direction of the approved sketch.

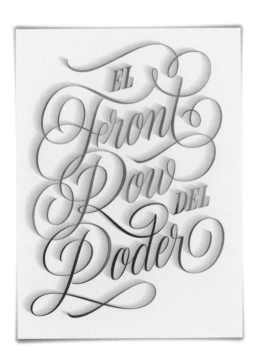

✓ Make a list of requested changes to incorporate

✓ Ask the client if you are unsure about what revisions to make

✓ Double check that you have performed all changes before sending your revised sketch

✓ Make sure the sketch is approved before moving on to the digital drawing

The client suggested a background color change

Digital Drawing

As we have learned in chapter 8, digitizing your drawing is the most time-consuming part of lettering. Since some details are still undefined in a rough sketch, the digital drawing also involves further decision-making. You may therefore want to share an early draft with your client, to confirm again that you are moving in the right direction.

After presenting your digital drawing, there may be a round of changes, typically involving details or color changes that you can take care of promptly.
Before you deliver the final result, you will want to make sure that the art director or editor is happy with the revised version and ready to receive final files from you. Politely ask if everything looks fine, and if so, you can start preparing the files. Now you are ready to wrap up the job!

✓ The approved rough sketch is the basis of your work

✓ Add details

✓ Get feedback before preparing final files

Flatten all layers and delete unused layers

Convert all elements to outlines
merge letter shapes

Check color mode and bleed setting

Delivering Finals

Convert all elements of your lettering, including any fonts you may have incorporated, to outlines, so that your artwork can be scaled without changing the proportions of the components of your design. If you have kept letter shapes separate from each other, merge them now.

If not specified in the initial briefing, find out from your client whether you need to allow for bleed, which is usually the case for print products. Bleed is basically an extra amount of image that extends the intended trim size. It is added as a safety measure to ensure that an image is not cut off when the paper is trimmed. The bleed is usually about .125 to .2 inches.

Make sure the color mode matches the needs of the client. Normally you will deliver a CMYK file if your piece is intended for print and an RGB file if it is intended for digital uses. Make your final files available for download online. That will keep you from having to send large files by email and will make it easier for your client to share them internally.

Lettering for AIGA's "Eye on Design" blog. AD: Perrin Drumm

Once the client has approved your digital drawing, you need to deliver your file—or files, if there are several versions, such as a black-and-white and color version—in the format the client has requested. Your drawing should be cleaned of all unused layers and colors, and, unless the client has explicitly asked you to deliver the file in layers, it should be collapsed into one single grouped object. This will avoid any possible shifting of elements in your piece.

Say good-bye and offer your help in case there are any issues later in the process. Let the client know that you have enjoyed working with him or her and that you are looking forward to future collaborations.

Timing

When working as a professional lettering designer, meeting deadlines is essential. Often your work will be used within a larger context, such as a magazine, an ad campaign, or a branding system, and if your work is delayed, it will influence the whole project. Delivering a job late will cause a domino effect that will impact not only the people you work with directly but everyone involved in the larger project.

Therefore, it is important that you take care of your own deadlines, regardless of your client's workflow. Your project will be just one of many the client company is dealing with simultaneously. If the art director or editor takes too long to give you feedback, it is okay for you to ask (always politely!) for it, so you can go on working.

In some cases a project will turn out to be more complex than you initially thought and therefore also more time-consuming. Communicate that in due course and ask if your deadline can be shifted. Oftentimes project managers pad their schedules, so you might be granted some extra time to work on the project. If you happen to finish the final artwork earlier after all, your client will always be happy to get it sooner.

	Monday 2	Tuesday 3	Wednesday 4	Thursday 5	Friday 6	Saturday 7
09	Send rough sketches					
10		Client feedback →	♡ milo's ♡ first day at preschool ♡	Digital drawing →	DELIVER FINALS	
11						
Noon	Call agent					Sleep in!
13						
14		PORTFOLIO UPDATE			Prepare talk for ATypI	Brunch with friends
15	Call new client		check new projects of online workshops			
16			go grocery shopping			Water the plants
17						
18						

Getting Better

Making a career as a lettering designer depends on creating good artwork and building a portfolio of projects with happy clients. Those clients will come back for more work and will recommend you to other potential clients. There are two aspects to making clients happy: one is the quality of your work, and the other is the human factor. The former depends on the way you pay attention to and interpret the briefing, understand the client's feedback, and dedicate the time to the commission it needs. The latter involves facilitating an open and smooth creative process, being kind and easy to work with, and sticking to deadlines at all times. Always keep in mind that you are working with people. Be courteous, empathetic, professional, and proactive, and contribute ideas. Deliver good work within the set time frame.

Now that we find ourselves near the end of this book, it is time to unveil an uncomfortable truth: your pieces will never be finished. In a few years, if you look at an artwork you did today, you will probably want to change parts of it, if not the whole thing!

Iterations of your design can go on forever, and there is always room for improvement. Therefore, it is essential to set a limit. This may come from a client who defines a deadline, or it may come from yourself, because you think a design is "good enough."

But when the goal is to deliver a great piece of work, how good is good enough? This perception will change with time as your skills improve and, correspondingly, your standards rise.

The line that defines whether a job is finished or not is very blurry. On the one hand, refining a piece indefinitely keeps us from moving on to other things. In the case of a commercial project, it also creates the danger of not meeting the deadline. On the other hand, a refinement process that is cut short might lead to a poor result.

Determining the level of quality a work must have to be considered finished is not easy, but in time, with practice, you will acquire a feeling for when a piece is done.

Because repetition improves your memory, practicing is crucial to raise the quality of your creative work. This way you will build a library of letter shapes and concepts that will show up naturally in every piece you make.

Checklist for Good Lettering Design

Of course, creating high-quality work is the most important factor in making a reputation for yourself as a professional lettering designer.

Everything you create and put out there will stay there for a long time. Therefore, setting standards for your work is an essential part of your statement as a professional. Where in the creative world do you want to stand and what kind of contribution do you want to make?

Nowadays lettering is everywhere! Social media has triggered this boom and influenced many to make a go of lettering professionally. There are so many talented lettering designers that the only way to stand out is by doing good work consistently. But what defines good work?

Throughout the years I have put together a series of standards I have set for myself to deliver high-quality work, a sort of checklist for each one of my projects.

Standards change with time and depend on the person setting them. You can read my standards on this spread, but I'm sure you will soon create your own standards for your own work.

✓ *Consistency*

As we have learned, the letters in the alphabet share certain shapes and features. Therefore, if I decide to work with a certain type of serif, I should be able to apply this design decision to every letter of my piece. This does not mean that I copy and paste the exact same serif on every letter; rather, I adjust its basic shape according to the nature of each letterform. This way my design will look consistent, and the letters will "speak the same language." The same is true for calligraphic style. To make the design consistent, all letter strokes need to be executed with the same tool, by the same hand, and at a consistent speed.

✓ *Detail*

Its richness of detail is what differentiates lettering from other typographic forms. Since lettering designers are dealing with a limited set of letters and words, they can work with a level of detail and embellishment that type designers cannot.

A type designer focuses on creating a complete functioning alphabet that works in all possible combinations (including punctuation marks, diacritics, numbers and other components of a font). Adding a great amount of detail and adornment would simply make the project endless. Therefore, a font cannot perform the same kind of tasks that lettering can. As a lettering designer can add several layers of intricate details and ornamentation in order to create a unique piece.

✓ One of a kind

Lettering is custom made for a specific purpose. Whether it is used for a storefront, a magazine cover, or an article illustration, the power of custom lettering is that it is tailored to that specific object or application. Its shapes, colors, and structure should be designed to work in perfect harmony with its context. Since we do not work with preexisting letters, we create one-of-a-kind pieces that cannot be used for anything else, which gives lettering design its unique character.

✓ Storytelling

Is my lettering conveying the message or story that I want it to convey? All the elements combined in my design, such as color, structure, letter shapes, and embellishments, should contribute to this ultimate goal. An artwork that conveys an unwanted message or the wrong atmosphere fails as a communication piece, no matter how pretty it is.

✓ Good letter shapes

Of course! The letterforms are the stars of my work. They should be consistent and beautifully crafted. As a letter designer, my main focus should lie in searching for the ideal shape for my letters.

For a beginner it may be tempting to cut the phase of letter refinement short and move on too quickly to adding color and texture. It might be appealing to make use of effects that promise to "enhance" your design.

Bear in mind, though, that a set of graphic artifacts and visual fireworks may possibly hide poorly executed letter shapes from uneducated eyes, but not the eyes of those who could potentially hire you for your next job.

✓ Creating something new

Lettering is a craft that dates back centuries, which allows us to get inspiration from a rich pool of historic styles, shapes, and features. At the same time, we should pay attention to the work of contemporary artists and designers.

Getting inspiration, however, neither means replicating a vintage design nor trying to emulate a contemporary lettering designer. Your work should always aim to bring something new to the scene—find your own voice rather than creating more of what already exists.

Acknowledgments

Many thanks to all the people from whom I learned letter design: Peter Bil'ak, Erik van Blokland, Peter Verheul, Paul van der Laan, Françoise Beserik, Gerard Noordzij, Ken Barber, Lucas de groot, and many others who directly or indirectly contributed to my education. Special thanks to Tomas Mrazauskas and to my agents at Handsome Frank, who truly helped me build my portfolio of work. Many thanks to Giuseppe Salerno, Elmo van Slingerland, and Frank E. Blokland for their fantastic calligraphic contributions to

this book, and to Verlag Hermann Schmidt and Bertram Schmidt-Friederichs, who helped me shape these pages and make them shine. Thanks to my husband Ilja for his constant support (and his work on some of the pages of this book). And thanks also to my son, Milo, for playing quietly next to me while I was meeting this book's deadlines, although he was still only a baby. To my mom and dad, thank you.

Martina Flor

Selected Bibliography and Recommended Links

Cheng, Karen. *Anatomie der Buchstaben* [Anatomy of letters]. Mainz: Verlag Hermann Schmidt, 2006.

Congdon, Lisa. *Art, Inc.: The Essential Guide for Building Your Career as an Artist.* San Francisco: Chronicle Books, 2014.

Graphic Artist's Guild. *Handbook of Pricing and Ethical Guidelines.* New York: Graphic Artists Guild, 2013.

Highsmith, Cyrus. *Inside Paragraphs: Typographic Fundamentals.* Boston: Font Bureau, 2012.

Hildebrandt, Gesine, and Jim Williams. *Schrift wirkt! Einfache Tipps für den täglichen Umgang mit Schrift* [Writing works: simple tips for everyday use]. Mainz: Verlag Hermann Schmidt, 2012.

Hong, Geum-Hee. *Brush 'n' Script.* Mainz: Verlag Hermann Schmidt, 2010.

Noordzij, Gerrit. *The Stroke: Theory of Writing.* London: Hyphen Press, 2005.

Pott, Gottfried. *Kalligrafie: Erste Hilfe und Schrift-Training mit Muster-Alphabeten* [Calligraphy: first aid and writing training with alphabet templates]. Mainz: Verlag Hermann Schmidt, 2005.

Pott, Gottfried. *Kalligrafie Intensiv-Training* [Calligraphy: intensive training]. Mainz: Verlag Hermann Schmidt, 2006.

Pott, Gottfried. *Schreiben mit Hand und Herz. Kalligrafische Erfahrungen* [Writing by hand and heart: calligraphic experiences]. Mainz: Verlag Hermann Schmidt, 2016.

Stawinski, Gregor. *Retrofonts.* Mainz: Verlag Hermann Schmidt, 2009.

Matthew Butterick, *Butterick's Practical Typography,* www.practicaltypography.com

Tobias Frere-Jones, *Frere-Jones,* www.frerejones.com

Allan Haley, "Type Classifications," *Fontology,* www.fonts.com

Yves Peters, "Figuring Out Numerals," *The Font Feed,* www.fontfeed.com

Paul Shaw, "Script Type Terminology: A preview of a new book," www.paulshawletterdesign.com

Ilene Strizver, "Punctuations," *Fontology,* www.fonts.com

@martinaflor

Photo by Jules Villbrandt

Martina Flor combines her talents as designer and illustrator in the drawing of letters. She grew up in Buenos Aires, where she studied graphic design and worked as an illustrator and art director for many years. After obtaining a master's degree in type design from the Royal Academy of Art in The Hague, she founded her own studio in Berlin.

Specializing in lettering and type design, she works for publishing houses, agencies, and private clients around the globe. Flor cofounded the online competition Lettering vs. Calligraphy, which garnered a lot of attention, and she has also initiated numerous other noncommercial projects, including Letter Collections, a collection of postcards. Her series of lettering work-shops called "Good Type" is now also available on two online platforms (Skillshare and Domestika) in two languages (English and Spanish).

When she is not busy drawing letters, Flor teaches at several universities and travels around the world to host workshops or speak at design conferences. With her work, she has helped establish lettering design in the European design scene and has become a leader in the industry.

First published in the United Kingdom in 2017
by Thames & Hudson Ltd, 181A High Holborn,
London WC1V 7QX

British Library Cataloguing-in-Publication Data
A catalogue record for this book is available from
the British Library

ISBN 978-0-500-24152-3

Printed and bound in China

To find out about all our publications, please
visit **www.thamesandhudson.com**. There you
can subscribe to our e-newsletter, browse or
download our current catalogue, and buy any
titles that are in print.